Moustaches, Whiskers & Beards

LUCINDA HAWKSLEY

Moustaches, Whiskers & Beards

NATIONAL PORTRAIT GALLERY, LONDON

This book is dedicated to my bearded friend Javier.

It is also dedicated, with thanks, to all those
men who are no stranger to the razor.

Contents

The Early History of Facial Hair

Facial hair has been represented in art since the first cave person picked up a piece of charcoal and decided to draw a man. Early art also reveals that facial hair has long been tamed – usually by being clipped or plucked – suggesting that the all-important question of 'To shave or not to shave?' has been around for almost as long as humans themselves. Over the centuries facial hair has fallen in and out of fashion. Hairy faces have been lauded, derided, commemorated in art and even legislated against.

In ancient Egypt, for example, shaving was associated with cleanliness, so priests shaved themselves entirely and would then wear a stylised false beard for ceremonial purposes. Surviving Egyptian art suggests that non-priests also wore false beards, in this case to emphasise that they were followers of the god Osiris. Pharaohs wore false beards of a particular design – one that splayed out at the bottom. The classic straight, plaited beard with a turned-up end, such as that known from the famous death mask of King Tutankhamun, would not have been a style worn by a pharaoh during life: this was a specific shape worn only

Alabaster bust of a bearded male figure from Uruk, Lower Mesopotamia, dating from the third millennium BC

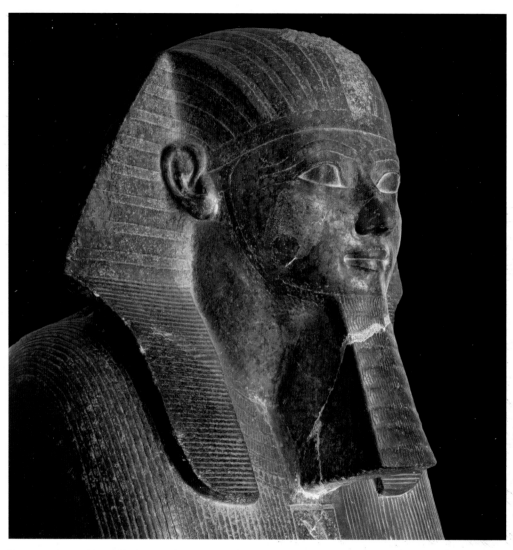

This representation of Queen Hatshepsut in the form of a sphinx wearing a false beard, now in the Egyptian Museum in Cairo, was made for her mortuary temple near Luxor and dates from the 18th Dynasty (c.1460 BC).

in death. Of course, it is impossible to know what the average Egyptian male looked like and if he did or didn't wear facial hair, as art doesn't tend to record the people who weren't famous or royal. Wearing a false beard became so fashionable that it was not confined just to pharaohs or even to adults. At the British Museum in London is the coffin of an infant: a mini mummy case complete with childlike features and a long stylised beard.

The ceremonial beard took on a whole new dimension in the 1400s BC, following the death of Thutmose II. His unconventional widow, Hatshepsut, decided that she did not want her young nephew (who was also her stepson, as she had married her brother) to succeed his father. Instead she declared herself the new ruler. In order to make herself appear more pharaoh-like, she began wearing a false beard – that, after all, was what rulers did. The images that survive of Hatshepsut are remarkable for the way in which her representations change from showing her as a sexually alluring female, with clearly defined breasts and waist, to that of a more masculine-looking and therefore acceptable pharaoh; finally evolving into a beard-wearing sphinx.

Of course, shaving, as we know it today, wasn't possible before the discovery of metals. In the earliest times men plucked out their facial hair – archaeologists have discovered ancient 'tweezers' made of hinged seashells or bones – or they used pumice stones to slough it away. In fact, many millennia before the word

> **'Of the antiquity of the custom of wearing the beard there can be little doubt, since, unless Adam was the first barber, as well as gardener, he must have worn the old ornament to his chin with which God had furnished him; though nothing has shown the mutability of fashion, more than its cut, colour and curl, since the creation of man.'**
>
> *Bentley's Miscellany*, April 1846

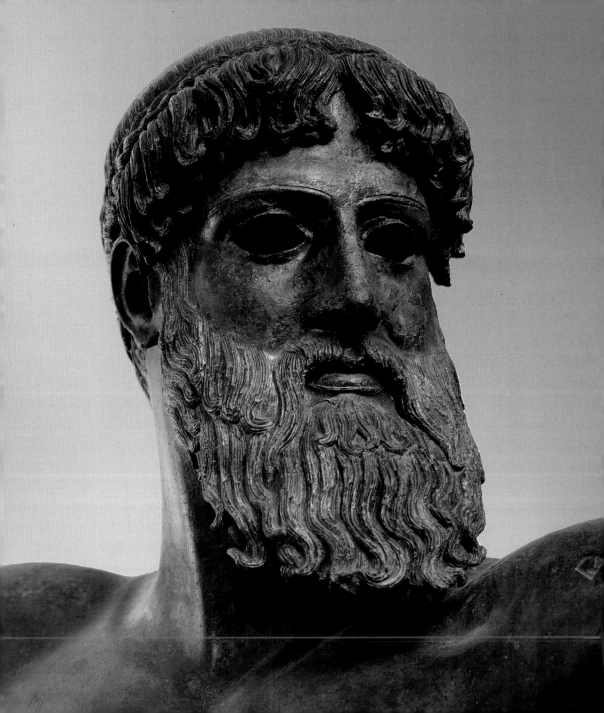

'metrosexual' was even thought of, the depilatory methods of waxing and sugaring were being used by men as well as women. (Sugaring, incidentally, involves applying a sticky paste of sugar or honey to the skin, then peeling it off and taking the hair with it.)

Archaeologists in Egypt have uncovered ancient razors, and the Greek writer and historian Herodotus recorded in 440 BC that in Egypt 'priests shave their whole body every other day, that no lice or other impure thing may adhere to them when they are engaged in the service of the gods'. He also revealed that when they were in mourning, the priests stopped shaving, allowing their hair and beards to grow until the mourning period was over.

Herodotus himself was rather scornful of such behaviour, as his Greek contemporaries were very proud of their beards. Indeed, being able to grow a full beard at that time was a sign of high status and wisdom. Many statues show notable Greeks with fine curly beards, even if the sitter's own beard wasn't quite as lustrous as the sculptor depicted it. Many Greek men wished to emulate the gods Zeus and Heracles, both of whom are defined in art by huge beards. Ancient Greek men would also use hot tongs to make their beards hang in long, lustrous curls.

The men of ancient Rome had a more ambiguous relationship with beards. They found the long curled beards of the Greeks somewhat off-putting, and those Romans who chose to wear beards tended to keep them clipped and neat. Lucius Tarquinius Priscus, King of Rome in the sixth century BC, is said to have introduced the razor to his countrymen and tried to encourage the habit of shaving. A century later, the fashion had finally caught

The head of a bronze statue of Zeus by an unknown sculptor, dating from c.460 BC and found on the sea bed off Cape Artemision, northern Euboea (now Evia), in 1926.

on. By the second century BC, Pliny was reporting that the Roman general Scipio Africanus shaved every day. As fashion was dictated by the whim of the current emperor, when Hadrian, in the first century AD, wore a beard to disguise his blemished skin, facial hair once more became fashionable.

Throughout history, wearing facial hair or choosing to be clean-shaven has often become symbolic of a generational difference. In the ancient world, older men equated beards with sagacity, but as the fashion for shaving grew more widespread, younger men began to ridicule the sight of a man with a full beard. In the first century AD, Lucian of Samosata, a Greek satirist and writer, famously commented, 'If you think that to grow a beard is to acquire wisdom, a goat with a fine beard is at once a complete Plato.' This attitude would wax and wane throughout history as those with and without beards vied for superiority. In the fourth century AD, Ammianus Marcellinus, a Roman soldier, writer and historian, wrote to his fellow men, 'Do you suppose that your beard creates brains …? Take my advice and shave it off at once; for that beard is a creator of lice and not of brains.'

The Greeks' famed love of beards was to change under the leadership of Alexander the Great (356–323 BC). The Macedonian-born commander, who led the Greek Empire against the Persians, insisted that his soldiers shave before battle. His reasoning was that, in close combat, a beard could be grasped and used to pull

Beards and Barbarians

There is a widespread belief that the word 'barbarians' derives from *barba*, the Latin word for beard. Sadly etymologists dispute this strenuously, which is a pity, as it makes for a good story that, in ancient times, those nations whose men wore beards were those that became known as 'barbarians'.

an opponent off his horse. He therefore hired an army of barbers to shave his soldiers on the night before a battle.

Several centuries after the death of Alexander, people in Britain grew to distrust facial hair as much as the Macedonian general had done. The British Isles were under constant attack from a new and terrifying bearded scourge: the Vikings. It is usual for Vikings to be depicted with enormous unruly beards and moustaches and long straggly hair – indeed, this is what history classes still teach children about Viking hordes – yet Scandinavian archaeologists are quick to point out that these depictions are at odds with what they have discovered. One of the first myths to be dispelled is that of dirty, unkempt hair and beards, for among the most prevalent possessions found in Viking burial sites are grooming tools such as combs and tweezers, plus toothpicks and tools for cleaning beneath the fingernails. Vikings, it is now claimed, were possibly far more hygienic and much better groomed than their British opponents.

Several of the world's major religions have very strict rules about the growth and maintenance of facial hair. And sometimes even subgroups within a religion have different rules from each other. This has certainly been the case within Christianity, where several factions have changed their minds on numerous occasions about whether or not facial hair is acceptable. Pope Leo III, who became head of the Roman Catholic Church in the final years of the eighth century AD, is famed as the first pontiff to be clean-shaven, and Catholic priests were expected to follow his example. On the

HENRCVS 1ͥ

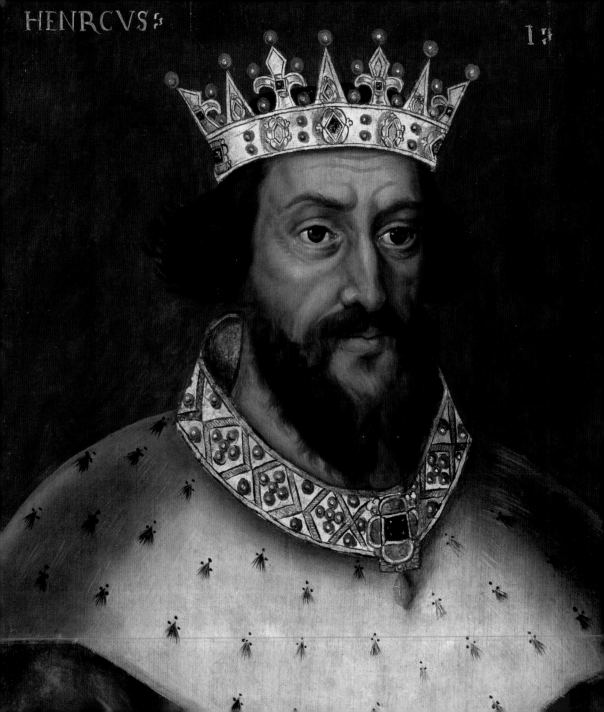

other hand, priests belonging to the Greek Orthodox Church were still expected to have facial hair. The next bearded pope did not appear until the sixteenth century, when Pope Julius II grew facial hair, temporarily, as a mark of mourning. He was repeating the ancient Egyptians' practice of not shaving for the seventy days of mourning their dead.

During these dark centuries for the bearded Christian, the Catholic Church waged a war on whiskers, Pope Gregory IV wrote a ninth-century diatribe against bearded priests, and by the early 1100s this pogonophobic feeling had spread to encompass not only priests but also all male worshippers. At mass on Christmas Day in 1105, a Bishop Godfrey was said to have refused Holy Communion to any man who had come to church unshaven. By this date the beard was being perceived in Britain as blasphemous and 'unchristian'. In the same year, the French bishop Serlo of Séez compared bearded men to 'goats and Saracens'. His sermon was delivered in the presence of the English king Henry I, who had resolutely kept his beard and thus incurred his Church's displeasure. The Anglo-Norman monk and chronicler Orderic Vitalis also railed against the King's beard. In the face of such public opposition, Henry was eventually induced to shave.

The bishop's comment about Saracens had great political clout at that time. During the Crusades – the battles Christians waged against Saracen Muslims to regain the Holy Land – it became a sign

'The cutting of the hair of the beard, which is said to be nourished by the superfluous humours of the stomach, denotes that we ought to cut away the vices and sins which are a superfluous growth in us. Hence we shave our beards that we may seem purified by innocence and humility and that we may be like the angels, who remain always in the bloom of youth.'

Gulielmus Durandus, *Rationale divinorum officiorum*, 1459

of Christian piety to be beardless. This somewhat bemused the Saracens, who regarded facial hair as a sign of virility and therefore perceived their Christian opponents as oddly feminine. One notable Crusader who declined to shave, however, was Baldwin II, King of Jerusalem, who was crowned in 1118 and married the daughter of an Armenian prince. Known sometimes as 'Bearded Baldwin' or 'Baldwin the Beard', he famously extorted a large 'ransom' from his father-in-law, Gabriel, for whom the wearing of a beard was an essential sign of manhood. The story goes that Baldwin, aware of Gabriel's abhorrence for shaven faces, claimed he had 'mortgaged' his beard for the enormous sum of 30,000 gold bezants in order to fund his army. So horrified was Gabriel at the thought of a beardless son-in-law that he paid the astronomical sum to ensure his daughter's husband kept his facial hair intact.

By medieval times the Crusaders' choice to have shaven faces was increasingly outmoded. That later warriors would happily grow large beards is proved by medieval armour: helmets survive that were specially fashioned to accommodate a beard. The four-teenth-century knight Edward, Lord Despenser, is depicted with a face covered by chain mail, yet with his dapper moustache still visible as it flows over the edges of his armour. The same can be seen in the National Portrait Gallery's copy of a medieval statue of Edward, Prince of Wales (known as the 'Black Prince' after his black suit of armour). The tails of his long moustache break free of the chain mail that covers most of his face and turn the statue into a distinctive portrait, rather than simply another anonymous knight in armour.

Edward, Prince of Wales (the 'Black Prince'). This electrotype by Elkington & Co., cast by Domenico Brucciani in 1875, is based on an effigy of c.1377 by an unknown artist made for the Prince's tomb in Canterbury Cathedral (detail)

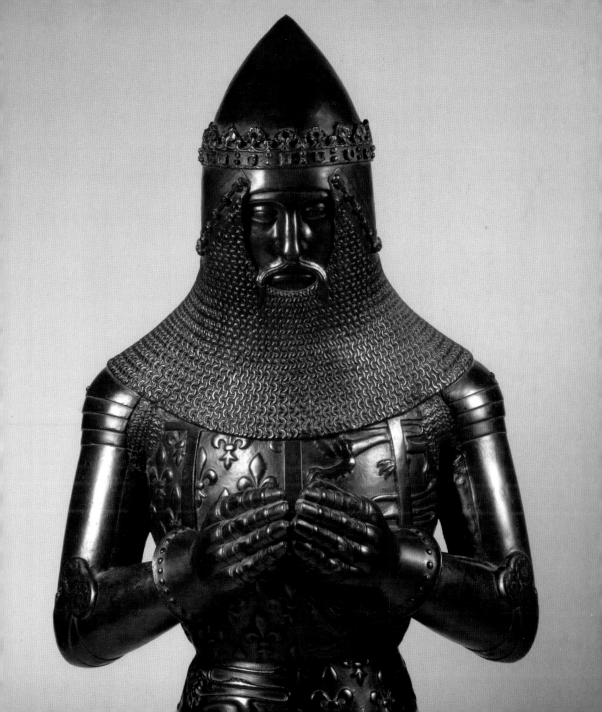

Recipes, Taxes and Elizabethan Beards

By the Middle Ages, facial hair was not only a sartorial choice. In one medieval treatise is printed the belief that growing a beard would cure an ailing man of toothache (what a woman with toothache should do is not recorded). It was, however, still a battle for facial hair to be accepted. A cartoon on an exchequer roll of 1233 from the city of

An anti-Semitic cartoon on a Norwich exchequer roll of 1233

Norwich shows an anti-Semitic illustration intimating that beards, as a symbol of the Jewish faith, should be feared and despised. At this time, Jewish people in England were persecuted by the Catholic Church, and the cartoon depicts a wealthy Jewish money lender with three faces and three beards, the 'triple beard' being to associate him with the devil. The illustration presages another change when, once again, beards would fall so firmly out of fashion that they would become the subject of laws and legal battles.

One of the first anti-beard laws was introduced in France in 1535. The Edict of Beards, as it has become known, forbade any bearded man from entering the law courts. This meant that anyone, even the victims of crime hoping for reparation, had to be clean-shaven before justice could be done. According to some sources, entry to the courts was also forbidden to those wearing 'clothing of a dissolute character'.

DEATH BY BEARD

In the sixteenth century, the Austrian town of Braunau had a mayor with a claim to fame: his beard was longer than he was tall. The mayor's name was Hans Steininger, and he was renowned for wearing his beard, which was approximately 2 metres long, tied around his waist in a special pouch. In 1567, however, there was a terrible fire in Braunau, Steininger's beard came untucked and he was killed when he tripped over it and broke his neck.

Today an epitaph to Hans Steininger can be seen in Braunau on an outside wall of St Stephan's church. The beard itself was preserved and can be visited in the town's museum. Steininger's death by beard is commemorated by World Beard Day (see page 135), which is deliberately held in September, the month in which he died.

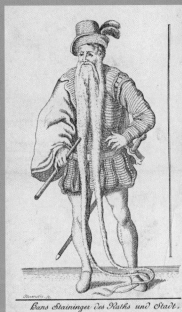

Hans Steininger depicted in a late-eighteenth-century illustration

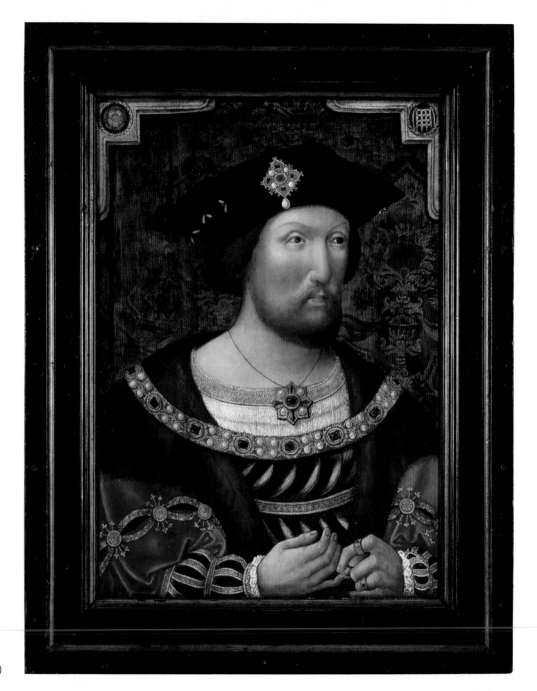

If rumour can be believed, 1535 was not a good year for beards, as it has been claimed that the bearded and moustachioed King Henry VIII introduced a tax on them. Henry himself vacillated between wearing a beard and shaving it off, as portraits and documents now in the Royal Collection attest. Of course, his tax would not have applied to himself, only to his subjects. Although this supposed beard tax has become famous and many mentions of it can be found in books and online, the National Archives has no documentary evidence that the tax ever existed.

It is possible that Henry VIII intended to impose a beard tax but that it was never passed. What is known, however, is that in 1536 the King added insult to an injury he had already caused in Ireland. When his troops took the town of Galway, Henry commanded that all male inhabitants should have their moustaches shaved off.

The Irish were not the only people to fear Henry's tyranny. One of the King's leading courtiers, Sir Thomas More, was executed for alleged treason on 6 July 1535. Although he knew he was unable to save his head, at the last minute he showed concern for the welfare of his beard. Having laid his head upon the executioner's block, More raised his hand, indicating that he was not yet ready for the axe to fall. He used the delay to position his beard so that it would not be severed by the blow. It was claimed that the last words he spoke were in defence of his beard: 'Pity that should be cut, that has not committed treason.' There are no portraits of a bearded Sir Thomas More in the National Portrait

'He that hath a beard is more than a youth, and he that hath no beard is less than a man; and he that is more than a youth is not for me, and he that is less than a man, I am not for him.'

Beatrice in William Shakespeare's *Much Ado About Nothing*, c.1598

THE WIDDOWES TREASURE

John Partridge, an apothecary, published a book called *The Widdowes Treasure* in 1595. It includes a recipe 'To make the haire of the bearde grow' (alongside a recipe for quince marmalade).

Take cane rootes, Briony roots, Beetes, Radish, flower de Luce, Onions, of each a like the quantity of foure onces, five fatte figs brused and stamped very small, maiden haire, sothernwood, dill, of each a hanfull sœthe all these in good Wine, thé wring out the liquor and straine it through a strainer, then put to it fresh butter never salted, pure Honie two onces, Oyle of Almondes sweete and sower, Oyle of Selania on once, Orimell squillick, halfe an once, the pouder of meale, nigella, fenegreeke well sifted and throughlie boulted in a Boulter, one handfull of Grasse Labeanum on once, set there upon the fire and stirre them well till it be thicke. This Linament being applyed to the Chin and Cheekes, wil become haire: the body first purged from al filth inwardly, proved by experience.

THE VVIDOVVES TREASVRE

Plentifully furnished with sundry precious and approued Secrets in Physicke and Chirurgery, for the health and pleasure of Man-kinde.

Hereunto are adioyned sundry pretty Practices and conclusions of Cookery, with many profitable and wholesome Medicines for sundry Diseases in Cattell.

LONDON,
Printed by Eliz. Allde, and are to be sold by Robert Bird. 1631.

Title page of *The Widdowes Treasure*, a book 'Plentifully furnished with sundry precious and approved Secrets in Physicke and Chirurgery, for the health and pleasure of Man-kinde'

Gallery's Collection, so it seems likely he began growing his beard while imprisoned.

Despite having a bearded father, the son and heir of Henry VIII persecuted those with beards, perhaps because he was yet too young to grow one himself. In 1548, during the brief reign of the sickly boy king Edward VI, the Burghmote Book of Canterbury includes the entry: 'The Sheriff of Canterbury and another paid their dues for wearing beards, 3s. 4d. and 1s. 8d.' Either Edward had either imposed his own tax upon beards, or Henry's mysterious tax was passed, but no documents survive to prove it.

It is unrecorded whether Edward VI's successor, Lady Jane Grey, had any feelings of pogonophobia or pogonophilia during her turbulent nine days as queen, but it seems that the next monarch, Queen Mary I, did not share her half-brother's irritation with beards. In 1555 it was reported that Mary had sent four agents to Moscow to meet the tsar, Ivan the Terrible, himself the possessor of prodigious facial hair. According to legend, all Mary's agents had impressive facial hair, especially George Illingworth, whose beard was over 5 feet long. An encyclopedia from 1902 includes the following entry on Illingworth and his mission to Russia: 'At sight of [the beard] a smile crossed the grim features of Ivan the Terrible himself. George's beard was thick, broad, and yellow; and, after dinner, Ivan played with it, as with a favourite toy.'

If bearded Englishmen felt themselves protected by Mary I, they were to suffer more persecution during the reign of her

Singeing the King of Spain's Beard

Arguably, the most famous beard in Tudor England was not a real beard at all. When the British sailor and mercenary Sir Francis Drake reported to Queen Elizabeth I in 1587 that his men had attacked and set fire to Spanish ships in the port of Cadiz, he boasted that he had 'singed the King of Spain's beard'.

half-sister Elizabeth. Within months of her accession to the throne in November 1558, a row broke out in the law courts of Lincoln's Inn in London. As Walter Thornbury recorded in his 1878 book *Old and New London*:

In the first year of Queen Elizabeth it was ordered 'that no fellow of the house should wear a beard of above a fortnight's growth under penalty of loss of commons [food], and, in the case of obstinacy, of final expulsion' ... it is on record that the student who wore a beard should pay double for his daily commons and dinner in hall.

The Lincoln's Inn order was short-lived – it was repealed in November 1562 – and it was perhaps this that gave history the belief that Queen Elizabeth I, like her father, introduced a widespread tax on beards. In fact, men's facial hair began to thrive during the first Elizabethan era.

The new fad for facial hair can be seen in the portrait of Sir Richard Saltonston, a Lord Mayor of City of London during Elizabeth's reign. The entire lower portion of his face is smothered in an enormous moustache and a bushy beard, which his ruff has been designed to accommodate. A portrait of Sir Christopher Hatton, one of the Queen's Lord Chancellors, shows a similar arrangement, but in this case his moustache gives him the appearance of a twentieth-century film idol. The Lord Mayor of 1599, Sir Nicholas Mosly, has much neater facial hair than his

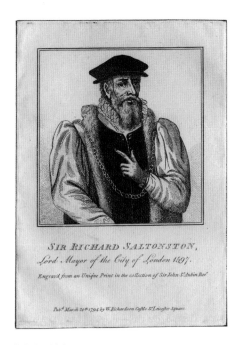

SIR RICHARD SALTONSTON,
Lord Mayor of the City of London 1597.

Engrav'd from an Unique Print in the collection of Sir John S.t Aubin Bar.t

Pub.d March 20.th 1794 by W. Richardson Castle S.t Leicester Square

Sir Richard Saltonston in a line engraving published by William Richardson, 1794

Sir Christopher Hatton by an unknown artist, c.1580

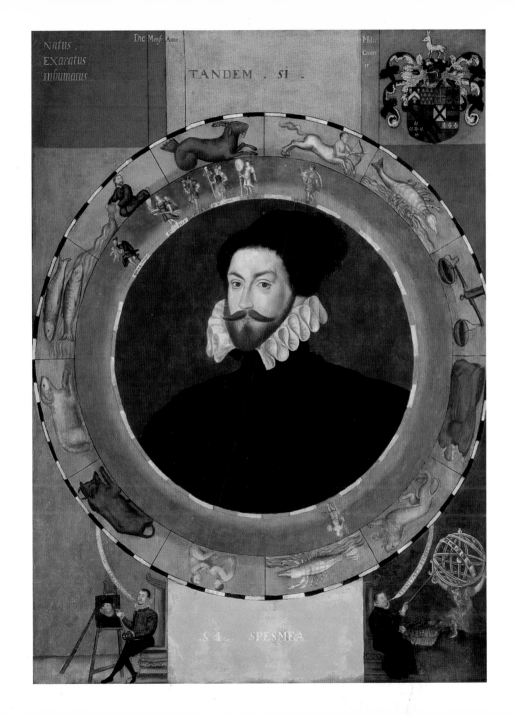

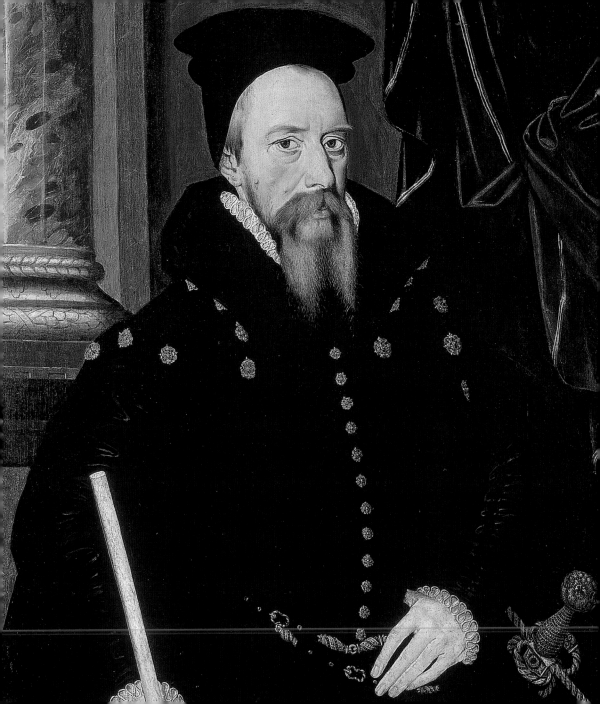

predecessor, consisting of a goatee and a wispy moustache. A decade later, Lord Mayor Sir Thomas Campbell had a full beard and moustache but kept it neatly trimmed.

Many of Elizabeth's advisers were heavily bearded, and facial-hair fashions during her reign seem to have grown outlandish. William Cecil, 1st Baron Burghley, who was Lord High Treasurer to the queen, appears proudly in his many portraits with an enormous drooping moustache that joins forces with his forbidding forked beard. One of Elizabeth's favourite courtiers, the Earl of Essex, also grew a pointedly forked beard to rival that of William Cecil. Essex was reputedly clean-shaven for most of his adult life, but in a testosterone surge after taking the Spanish town of Cadiz, he decided to let his facial hair grow unchecked. This is confirmed by a Venetian observer, who commented that on the boat back to England after the battle, Essex 'on this last voyage ... began to grow a beard, which he used not to wear'.

The beard grew quickly and furiously, and by the time Essex was painted in his full Knight of the Garter regalia around 1597, his orange beard was straggling over his ruff, as though attempting to join forces with the thick, rope-like cords that fastened his cloak.

Another of the Queen's favourites was Robert Dudley, 1st Earl of Leicester, who kept his facial hair much more subdued than his rival's. Instead of a badger-like beard, Dudley chose to sport a neat

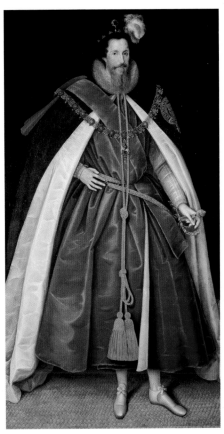

Robert Devereux, 2nd Earl of Essex, by Marcus Gheeraerts the Younger, c.1597

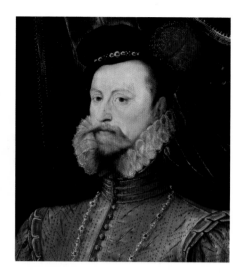

Robert Dudley, 1st Earl of Leicester, by an unknown artist, c.1575 (detail)

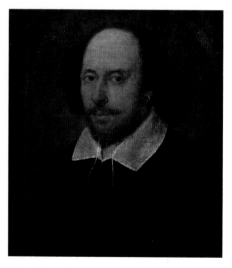

William Shakespeare, in a portrait attributed to John Taylor, painted during the first decade of the seventeenth century

goatee, which was surmounted by a splendidly long moustache framed by clean-shaven cheeks. His facial hair style was similar to that adopted by William Shakespeare, whose portrait shows him wearing a short beard, closely trimmed whiskers and a sedate moustache, set off by the gleaming brilliance of a gold earring.

A courtier whose facial hair appears to have changed in style according to who was on the throne was Sir Thomas Gresham, a wealthy merchant who was politically astute enough to survive being of service to three monarchs – Edward VI, Mary I and Elizabeth I. Depictions of Gresham during the reign of Edward show him with shaved cheeks, a neat moustache and an unremarkable beard trimmed close to his face. By the reign of Elizabeth, Gresham's facial hair has taken on a life and personality all of its own. In his portrait by an unknown Dutch artist of around 1565, he has an enormous Titian-coloured moustache, bulging beard and whiskery cheeks.

When King James I acceded to the English throne in 1603 (uniting England and Scotland), men's facial hair seems to have been rather better tamed than under the reign of Good Queen Bess. Perhaps the men of the royal court felt less threatened with a man at the helm and did not feel the need to show such overt displays of masculinity. King James I

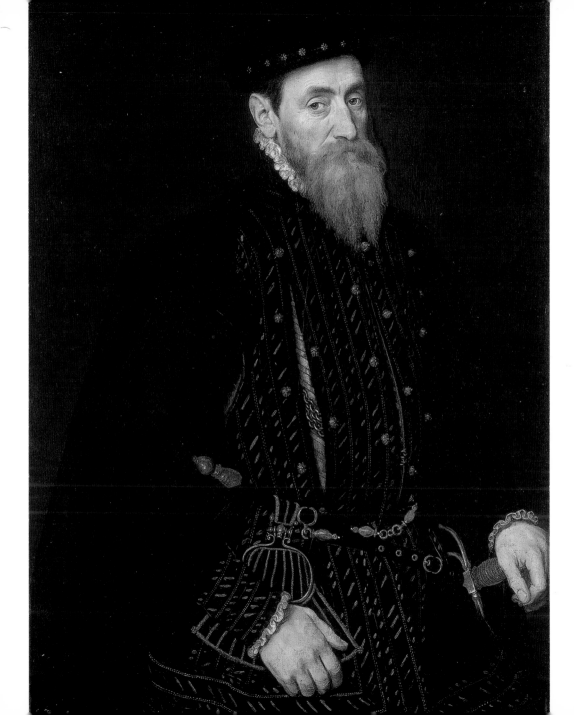

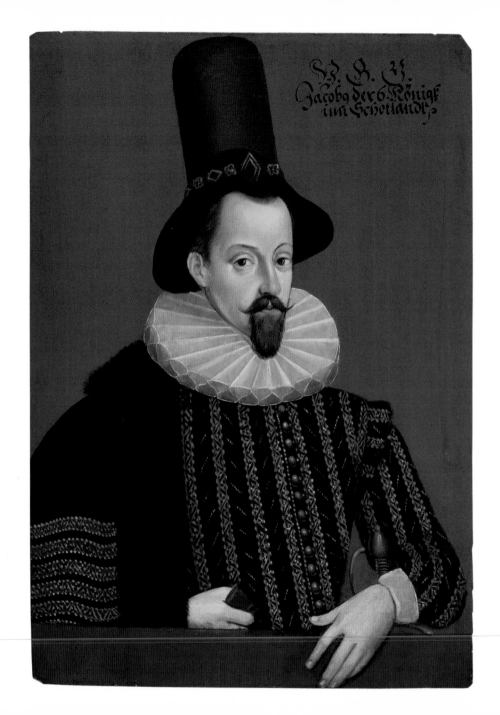

kept his face clean-shaven along the edges, but he was proud of his goatee beard and natty moustache. This fashion was emulated by the gentleman of his court, exemplified in the portrait of Thomas Coventry, 1st Baron Coventry, who held the trusted position of Lord Keeper of the Great Seal, and whose neat little pointed goatee and tidily curled moustache are a world away from the facial hair rampant in the hallways and walled gardens of Elizabethan palaces. The news that unruly facial hair was no longer in fashion does not, however, seem to have reached the ears of the King's physician, Theodore Turquet de Mayerne. His straggling beard and moustache seem deliberately to flout the laws of hygiene.

Outside the royal household, a plethora of facial hair can be observed on the faces of those men who plotted to blow up the King. Guido Fawkes (he preferred the exotic 'Guido' to the more pedestrian 'Guy') and his co-conspirators were immortalised in a group portrait after their plan was foiled. The dramatic image, by a now unknown artist, depicts eight men, all of whom look shifty and wear large beards that point out sharply from their faces, like the pointy chins of Venetian masks. They also have twirled moustaches that would have made Errol Flynn envious. The inference to be drawn from this image is that all Catholics were overtly bearded and not to be trusted.

Thomas Coventry, 1st Baron Coventry, by William Nelson Gardiner, early nineteenth century (detail)

Sir Theodore Turquet de Mayerne by an unknown artist, probably after 1625

Following pages: the Gunpowder Plot conspirators by an unknown artist, c.1605

James I of England and VI of Scotland by an unknown artist, c.1590

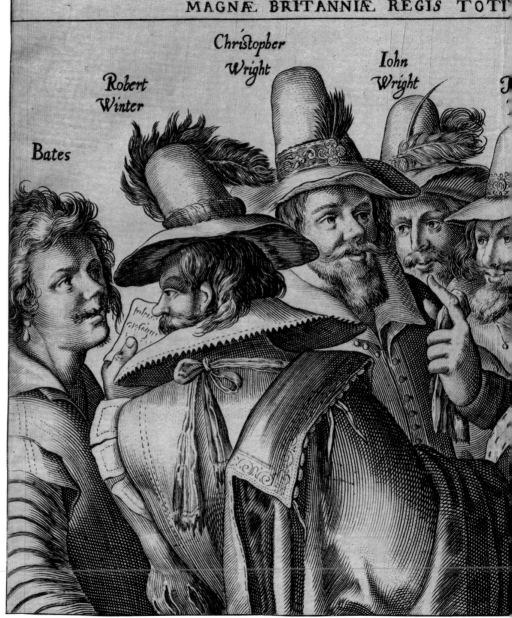

CONCILVM SEPTEM NOBILIVM ANGL OR

MAGNÆ BRITANNIÆ REGIS TOTI

Bates

Robert
Winter

Christopher
Wright

Iohn
Wright

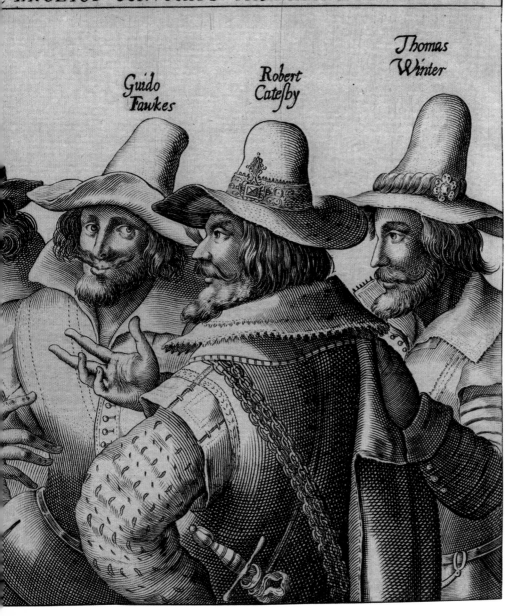

Guido
Fawkes

Robert
Catesby

Thomas
Winter

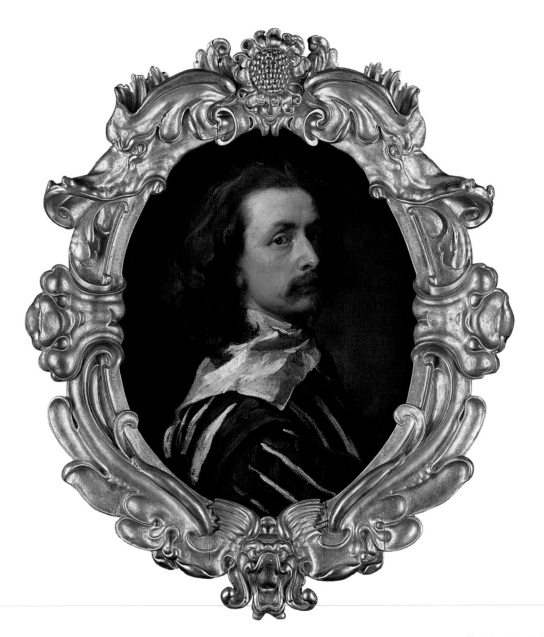

Sir Anthony Van Dyck,
self-portrait, c.1640

Roundheads, Regicide and Royalist Moustaches

Perhaps the English king most famous for his beard was Charles I, who came to the throne in 1625. Images in the National Portrait Gallery's Collection show him as a fresh-faced, clean-shaven young prince, while later portraits as king show him with his trademark handlebar moustache and pointed beard.

One of the most famous people to immortalise Cavalier facial hair was Sir Anthony Van Dyck, a Flemish artist who became the leading court painter in England. His self-portrait of c.1640, made shortly before his untimely death at the age of 42, shows a self-confident man looking boldly out at the viewer and displaying at close quarters his neatly kept moustache and fashionable small beard. His chosen style of facial hair is still remembered today: when men choose to cultivate a 'Van Dyck beard' they are copying the style of an artist who has been dead for almost four hundred years.

After Charles was arrested by followers of the Parliamentarian leader Oliver Cromwell during the English Civil War, he was imprisoned at Carisbrooke Castle on the Isle of Wight. Having previously taken great pride in his personal appearance and the cultivation of finely shaped facial hair, as seen in his portrait by Gerrit van Honthorst, the King

Sir Anthony Van Dyck

The Flemish-born artist Anthony Van Dyck became famous in England as King Charles I's court painter. Not only did his career manage to thrive despite the execution of his patron, but the artist's own appearance changed the way British men looked. Van Dyck became as renowned for his self-portraits as for his paintings of royalty. His c.1630 *Self-Portrait with a Sunflower* led a flurry of imitators to grow similar flowing moustaches and neatly trimmed beards.

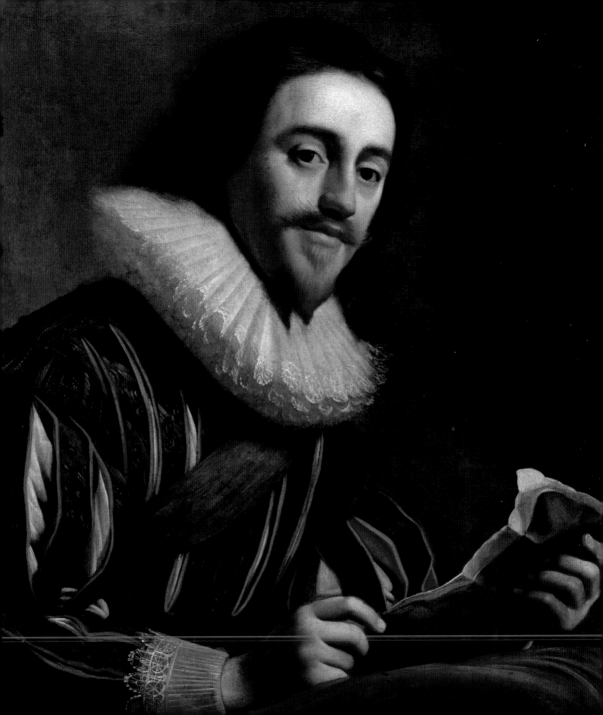

now refused to shave as he was denied access to his own barber. Understandably, he was loathe to allow a Parliamentarian barber's blade anywhere near his throat. From that moment on, his facial hair was allowed to grow unchecked.

When Charles I was beheaded on 30 January 1649, the executioner and his assistant wore false beards in an attempt to hide their identities from the angry Royalists. In the late nineteenth century, several relics that had been kept by supporters after the King's execution were interred in his burial vault at Windsor. These relics included a tooth, a fragment of bone from the King's severed neck and a portion of his beard.

The prize for best Royalist moustache, however, goes not to the King but to Arthur Capel. In his miniature portrait painted in 1647, he is depicted with a fabulously unusual moustache – thick, lustrous and swept back and upwards, like a pair of theatre curtains.

Unlike his father, the future King Charles II was already growing a moustache as a teenager, as can be seen in a portrait of about 1648 by Adriaen Hanneman. The man who became king eleven years after his father's execution usually chose to sport a debonair moustache, but without a beard or whiskers. He is most famously mimicked today in every depiction of Captain Hook from *Peter Pan*. The wicked captain is always shown with a lustrous black moustache, as in Sir Peter Lely's rakish portrait from about 1675. The author J.M. Barrie consciously

Arthur Capel, 1st Baron Capel, probably after John Hoskins, 1647

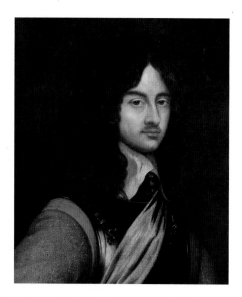

Charles II after Adriaen Hanneman, c.1648 (detail)

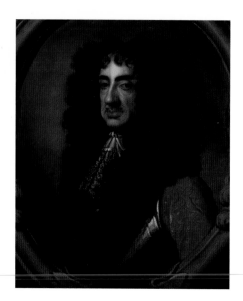

Charles II after Sir Peter Lely, c.1675

created his villainous pirate in the image of the long-dead King, describing him thus:

> A man of indomitable courage, it was said that the only thing he shied at was the sight of his own blood, which was thick and of an unusual colour. In dress he somewhat aped the attire associated with the name of Charles II, having heard it said in some earlier period of his career that he bore a strange resemblance to the ill-fated Stuarts.

Towards the end of his life, Charles chose to shave off his moustache, perhaps because it was no longer the glossy black it had been, or because, as he aged, his moustache hairs would no longer grow. In a portrait of around 1680, attributed to Thomas Hawker, the glum-faced King can be seen clean-shaven and looking rather dissolute.

One of the most famous portraitists in Britain during the seventeenth century was Sir Peter Lely. He painted his own portrait in 1660, the year of the Restoration of the monarchy, and he clearly favoured the King's sober approach towards facial hair. Lely portrays himself as a debonair man of the world, with a pencil-slim moustache carefully framing his mouth. The rest of his face is smooth and hair-free.

Charles II attributed to Thomas Hawker, c.1680 (detail)

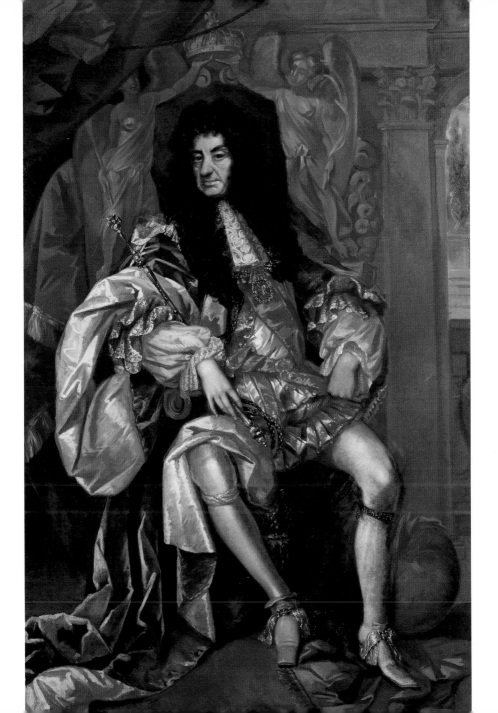

The Beard Tax
and New Fashions
in Facial Hair

The fashion for going beardless continued and was noticed by Tsar Peter the Great during his 'grand tour' of western Europe. On his return to Russia, he decided that his countrymen were looking old-fashioned and that facial hair was holding back Russia's fortunes and her reputation on the world stage. In September 1698 he called together all his nobles to voice his concern.

According to the now legendary story, Peter embraced each nobleman on arrival, then had his guest's beard snipped off with a pair of scissors. This happened to each of the noblemen in turn, and all were ordered to shave off the remains of their facial hair. This new rule applied to all men except priests. In his biography *Life of Peter the Great*, published around 1730, Jean Rousset de Missy wrote:

The tsar ... ordered that gentlemen, merchants and other subjects, except priests and peasants, should each pay a tax of one hundred roubles a year if they wished to keep their beards;

the commoners had to pay one kopek each. ... As for the young men, they followed the new custom with more readiness as it made them appear more agreeable to the fair sex.

In recent years, tokens have come up for sale at auction that were given as a receipt to those men who had paid the Tsar's tax. They are inscribed with the words: 'Beards are a ridiculous ornament.' The beard tax was not repealed in full until 1772.

Peter the Great was not the only tsar to make his dislike of beards worthy of political comment. On 28 October 1847 the *Devizes and Wiltshire Gazette* published the following article about Tsar Alexander II:

> Great preparations are on foot at Warsaw for the expected arrival of the Emperor [of Russia]. ... Every beggar is arrested, all the houses are being washed and painted, and the squares and public buildings are being beautified; and ... orders have been issued that all persons whose beards have been suffered to grow shall be shaved.

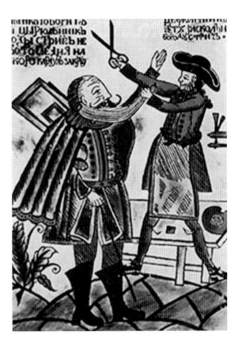

A Russian nobleman having his beard cut off by one of Tsar Peter the Great's servants

Perhaps Alexander was simply continuing Peter's legacy and expecting the rest of Europe to be as clean-shaven as his predecessor had found it. On his travels in 1698, Peter had spent several weeks in London and was greatly influenced by the fashionable men he encountered. Some of these can be seen in the National

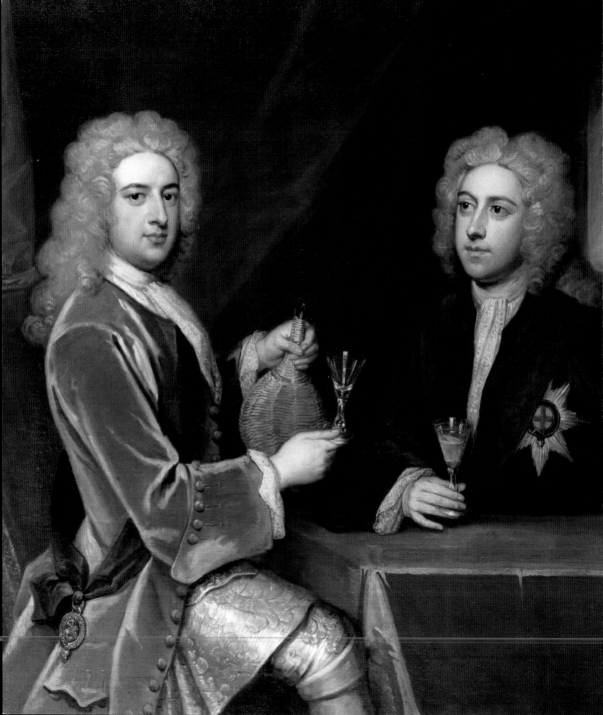

Portrait Gallery's collection of paintings by Sir Godfrey Kneller, known as the 'Kit-Cat Club' portraits. These date from the early 1700s and not a single facial hair is visible in any of the twenty-one portraits.

As the fashion for a hair-free face continued to hold sway in Europe, the barber shops rejoiced. The daily shave kept many establishments solvent and provided work for itinerant barbers. There were many who objected to paying for this service, however, and in the 1770s a French master cutler named Jean-Jacques Perret published his first book on the art of shaving oneself. Perret also invented a 'safety razor', but did not think to patent it, thereby forfeiting great riches. Within a short time, a number of newfangled razors, with varying degrees of the promised 'safety', were flooding the market. Designers all over Europe were getting in on the act and producing razors for men to shave themselves, including one with the bizarre name of the 'pig scraper'.

'If you teach a poor young man to shave himself, and keep his razor in order, you may contribute more to the happiness of his life than in giving him a thousand guineas. This sum may be soon spent, the regret only remaining of having foolishly consumed it; but in the other case, he escapes the frequent vexation of waiting for barbers, and of their sometimes dirty fingers, offensive breaths, and dull razors.'

Benjamin Franklin, *Memoirs* (written 1771–90)

One man who firmly resisted the lure of the pig scraper was the son of Lady Mary Wortley Montagu, an inveterate traveller and social reformer. Young Edward had been brought up with the love of travel in his blood, thanks to his father's role as British Ambassador to the Ottoman Empire. He spent part of his childhood in Constantinople (now Istanbul), being schooled in literature and eccentricity by his mother. In 1775 he was painted in what he called

Thomas Pelham-Holles, 1st Duke of Newcastle-under-Lyne and Henry Clinton, 7th Earl of Lincoln, members of the Kit-Cat Club, by Sir Godfrey Kneller, c.1721 (detail)

Turkish costume by the artist Matthew William Peters. Between his magnificent turban and robes can be seen a furrowed brow, nervous-looking eyes and a mass of wild, almost writhing facial hair that spills over his shoulders and down his chest. It is the portrait of a man who had, in the parlance of the day, 'gone native'. He had left England at a young age (having run away from school at least twice; once managing to escape as far from Westminster as Portugal) and had lived in the Middle East for many years before settling in Venice. A friend described him as having 'the manners, habit and magnificence of a Turk'.

Unfortunately for pogonophiles, Edward Wortley Montagu had left his homeland for good, and in Britain the beard was experiencing a low in popularity.

The Emergence of Whiskers

The beard may have been suffering a temporary setback, but facial hair was still thriving. Moustaches and exaggerated whiskers were coming into their own. In 1810, on the most fashionable streets of London, the name on everybody's lips was Baron Ferdinand de Géramb. He was said to have been a general in the Hungarian army and sported the most talked-about and flamboyant moustache in London, as well as a set of enviable whiskers. He is reputed to have been an enormous man, well over 6 feet tall and proportionately wide, and had arrived in London quite mysteriously on an English frigate that had sailed from Spain.

Edward Wortley Montagu by Matthew William Peters, 1775 (detail)

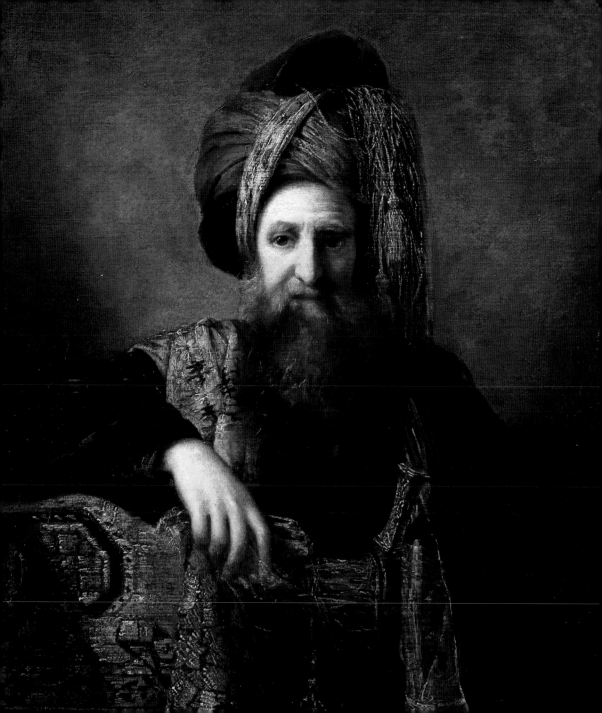

No one knew much about Géramb's past, or even whether he was truly a baron or Hungarian (it was later revealed that he came from an aristocratic French family forced to flee the Revolution).

'My beard I had once suffered to grow till it was about a quarter of a yard long; but as I had both scissors and razors sufficient, I had cut it pretty short, except what grew on my upper lip, which I had trimmed into a large pair of Mahometan whiskers, such as I had seen worn by some Turks at Sallee, for the Moors did not wear such, though the Turks did; of these moustaches, or whiskers, I will not say they were long enough to hang my hat upon them, but they were of a length and shape monstrous enough, and such as in England would have passed for frightful.'

Daniel Defoe, *Robinson Crusoe*, 1719

He did, however, arrive with a large amount of money, and immediately rented a luxurious house alongside fashionable Hyde Park. The stories about him spread: he was reputed to eat two chickens for breakfast and had apparently once killed three horses in a single day by riding them too hard. Somehow this led to him being praised as a hero – helped by the fact that he was a self-declared enemy of Napoleon, was a published poet and said to be a great favourite of the Austrian emperor. Following the tragic death of his beautiful young wife, it was rumoured that the Baron had become the lover of the Queen of Sicily.

The Baron's romantic reputation and much-lauded facial hair began a craze among young dandies in London, and, thanks to fashion magazines and newspaper articles, the desire to emulate his looks spread across the country. Other men, especially those in the military, began to wear their whiskers with pride – and perhaps with not a little irritation that the Baron's facial adornments had been singled out for notice instead of their own. Abnormally large whiskers can be seen over the next couple of decades in portraits of a number of prominent soldiers and trendsetters, including Arthur Wellesley,

1st Duke of Wellington; Robert Waithman, Lord Mayor of London; Ernest Augustus, Duke of Cumberland (a son of King George III); Lord Melbourne, a future prime minister; the engineer and inventor John Loudon McAdam and Beau Brummell, the most fashionable of all the Regency dandies.

On 19 June 1812, the *Chester Chronicle* published an article on the history of 'enormous whiskers':

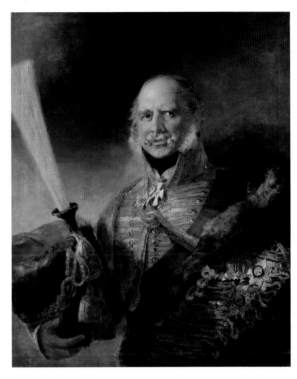

Ernest Augustus, Duke of Cumberland and King of Hanover, by George Dawe, c.1828

> The growing taste for enormous whiskers, introduced probably by the renowned Baron Géramb, brings to mind the following extracts from which it appears, that this appendage of the chin was formerly treated as a thing of great importance. The Tarters [*sic*] declared the Persians infidels, and waged a long war with them, because they would not cut off their whiskers. It is more infamous in Turkey to lose the beard than to be publicly whipped. To touch another's beard or cut off a little, was a token of love and protection amongst the first French, and all letters which came from the King had three hairs of his beard in the seal. In the reign of Catharine, Queen of Portugal, the brave John de Castro took the castle of Dru, in India – he borrowed from the inhabitants of Goa, 1,000 pistoles, as a security for which, he

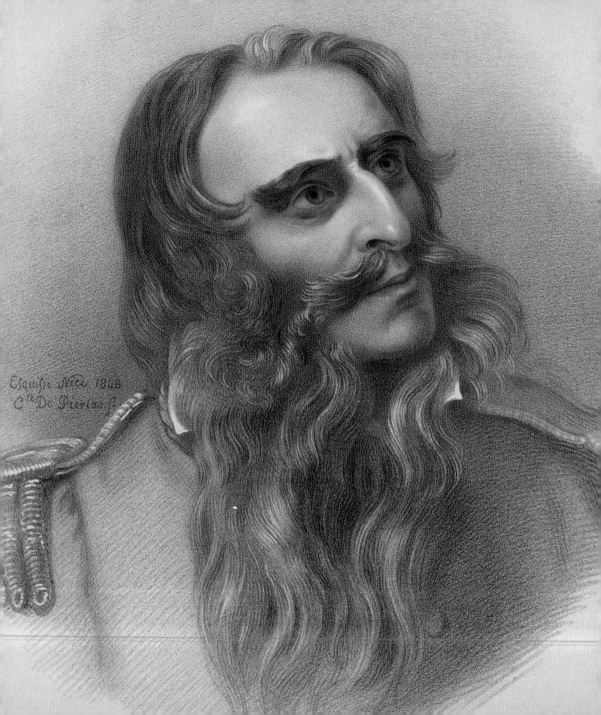

Esquisse Nice 1848
Ch De Pierlas f.

sent them one of his whiskers. The Turks when they comb their beards, gather the loose hairs, fold them in paper, and bury them where they bury their dead.

Hero-worship of the Baron was short-lived, however. Within a couple of years of his arrival in London, he was ignominiously ordered to leave Britain. The rumours of his later life include being kept in a Danish prison, being a prisoner of Napoleon, being shot and killed (several years before he did actually die) and being bravely rescued by one of his brothers. It was alleged that from 1812 onwards he declared himself a sworn enemy of England. Despite his personal disgrace, the legend of the Baron's facial hair lived on, and emulations of it can be viewed in portraiture of other military swashbucklers for several decades further. One of the best examples in the National Portrait Gallery's Collection is the portrait of Sir Charles James Napier, whose moustache and whiskers are so long and flowing that they cascade over his collar and down his chest, yet whose chin is clean-shaven and pristine.

Beard Vocabulary

The Greek word for 'beard' is *pogon*, and this is the basis of several beard-related terms:

Pogonotrophy is the art of growing and cultivating beards; wearers, barbers and others who help to groom or sculpt beards may be called *pogonotrophists*.

Pogonophilia refers to the love of beards; hence *pogonophile*, a lover of beards.

Pogonophobia is the name given to a fear or extreme dislike of beards.

With the Baron de Géramb no longer *persona grata*, the fashionable young men of London needed a new moustachioed hero. He appeared in 1813 when Thomas Phillips painted a portrait of George Gordon Byron – better known as the Romantic poet

Sir Charles James Napier in a lithograph by Richard James Lane, after Comte Hippolyte Caïs de Pierlas, 1849

Lord Byron – dressed in Albanian costume and wearing a delicate handlebar moustache.

Byron, famously labelled 'mad, bad and dangerous to know' by one of his discarded lovers, had a reputation not only for scandalous behaviour but also for adventure and siding with the underdog. When he acceded to his title and was welcomed into the House of Lords, he used his inaugural speech to bring the plight of the Luddites (workers fearful of advances in mechanisation) to the attention of those least likely to have thought or cared about the impoverished working man. When Byron died in 1824, while fighting in support of Greek independence from the all-powerful Ottoman Empire, he was hailed as a hero. His body was brought back to England and he was mourned by the nation. His early sexual indiscretions and the behaviour that had caused so much scandal in Britain was largely forgotten, but not by the Dean of Westminster Abbey, who refused to allow his burial there.

In 1813, Thomas Phillips' portrait of Byron had met with a lukewarm reception, but eleven years later, with the poet so heroically dead, it was a different story, and prints of the portrait were sold to Byron's admirers. As a result, even though the majority of portraits depict the poet as clean-shaven, it is Phillips' moustached Romantic hero that comes to mind for most people today. The writer Leigh Hunt, a friend of Byron's, described the portrait as 'by far the best ... I mean the best of him at his best time of life, and the most like him in features as well as expression'.

One fervent admirer of Byron was the author Charles Dickens. He hero-worshipped the poet to the extent that he took his family to Italy for a year so he could write where Byron had written. Most

George Gordon Byron, 6th Baron Byron, in Albanian costume, in a replica (made c.1835) by Thomas Phillips of his own original painting of 1813

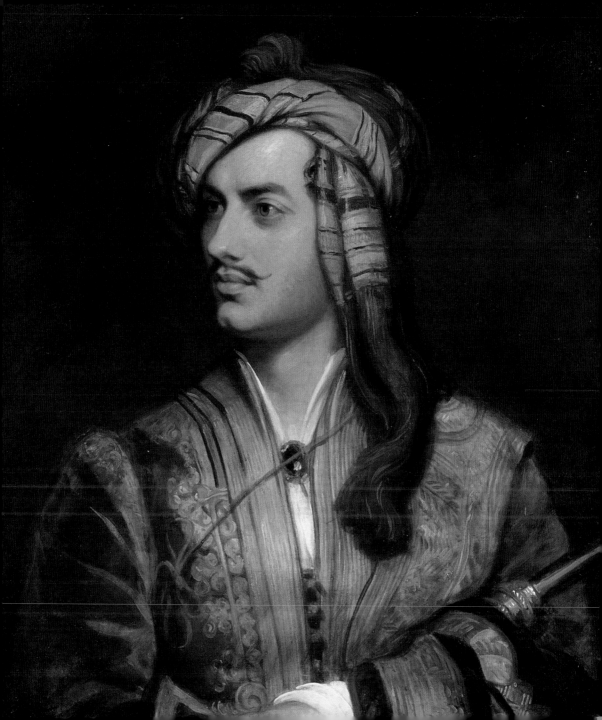

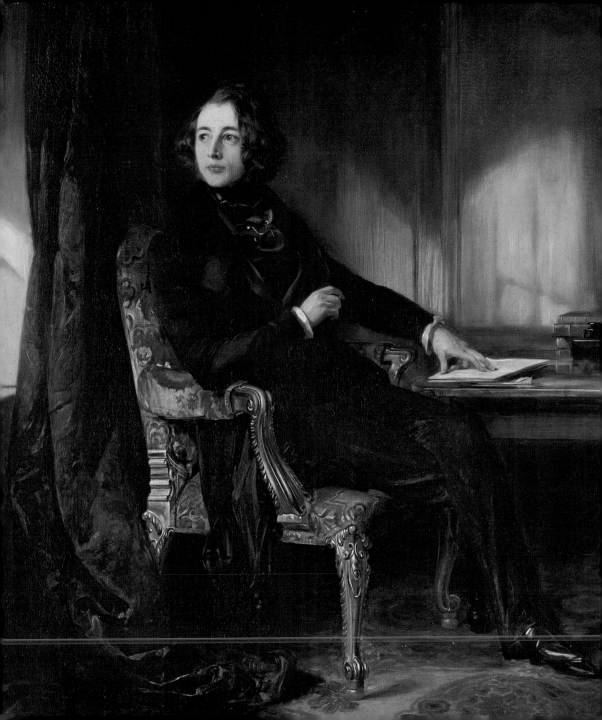

people today think of Dickens as bearded, but at the start of his career he copied the look of the Romantic poets: long hair and a clean-shaven face. This can be seen in Daniel Maclise's 1839 portrait, often known as the 'Nickleby portrait', because it was reproduced on the frontispiece of *Nicholas Nickleby*. This portrait was the first glimpse most people had of what the already famous author looked like. At the time of being painted by Maclise, Dickens was 27 years old. Throughout the 1840s he would experiment with facial hair, at first attempting a Byronesque moustache. In 1844, Dickens wrote wittily from Italy to Maclise: 'The moustaches are glorious, glorious. I have cut them short, and trimmed them a little at the ends to improve their shape. They are charming, charming. Without them, life would be a blank.'

'And people did say ... that when he began to have whiskers he left off having brains.'

Charles Dickens, *Dombey and Son*, 1848

Dickens vacillated between growing a moustache and being clean-shaven until the mid-1850s, by which time facial hair was immensely fashionable. For some time Dickens's great friend John Forster had been asking the painter William Powell Frith (who, himself, had spectacular mutton-chop whiskers) to paint Dickens's portrait. When Dickens grew another moustache, Forster considered it a 'hideous disfigurement' and asked Frith to wait until Dickens shaved. When Dickens began a beard as well, Forster reputedly told Frith he should start the portrait quickly, before the sitter's entire face was obscured.

In addition to writing novels, Dickens continued his career as a journalist and magazine editor. In 1853 he commissioned an article entitled 'Why Shave?' for his periodical *Household Words*. It

Charles Dickens by Daniel Maclise, 1839

WOMEN AND FACIAL HAIR, 1

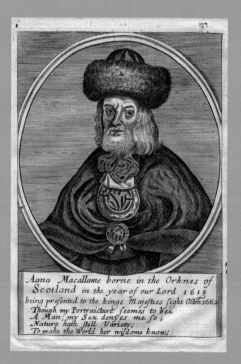

Anna Macallame in a line engraving by an
unknown artist, published in 1662

Since the beginning of time, some women have
sprouted facial hair, yet the idea of a woman with
a beard remains as much of a taboo now as it was
in the fifth century BC, when the Greek writer
Herodotus wrote his *Histories*. In those he noted that
people living near the city of Halicarnassus (now
part of Turkey) lived in fear of the priestesses at the
temple of Athena growing beards because it symbol-
ised that something terrible was about to happen.

The National Portrait Gallery's archives contain
two images of women with beards, both of whom
lived in the seventeenth century. Anna Macallame
was born in the Orkneys in Scotland in 1615 and was
'presented' to King Charles II in 1662. Her portrait
was published at this date alongside the following
rhyme:

> Though my Portraiture seemes to bee
> A Man; my Sex denyes me so;
> Nature hath still Variety;
> To make the World her wisdome know.

A few years after the birth of Anna Macallame, a baby girl was born in the German town of Augsburg; her entire body was covered with fine blonde hair. The hair continued to grow throughout her life, and as an adult she also had a full blonde beard. Barbara Urselin seems to have been exhibited as a curiosity from a very young age, and in her twenties she was brought to London by her husband, Michael Vanbeck, and billed as a woman with a 'thick beard' and the 'forehead of a lion'. The nineteenth-century writer G.H. Wilson observed:

> Her whole body, and even her face, was covered with curled hair of a yellow colour, and very soft like wool; she had besides a thick beard that reached to her girdle, and from her ears hung long tufts of yellowish hair. She had been married above a year, but then had no issue ... it is said [her husband] married her merely to make a show of her.

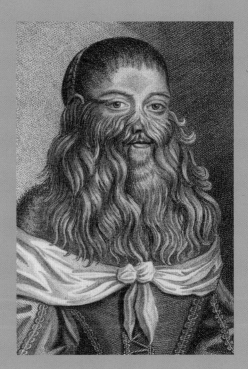

Barbara Urselin, born in Germany in 1629, depicted in a stipple engraving by G. Scott made in the late eighteenth or early nineteenth century

was written by the magazine's editor William Henry Wills, who went on to grow an enormous pair of whiskers that met beneath his chin in a neck beard, which made it look as though he was wearing an Elizabethan ruff.

The Victorian Love of Beards

In the 1860s, Dickens sat for a series of photographs at the studio of John and Charles Watkins. In them, he looks like an old man, an impression not helped by his unkempt, grizzled beard and moustache. Several of his friends and family members railed against his beard, disliking the way it changed his appearance, but Dickens ignored them and continued to champion what was becoming a widespread fashion for bigger, fuller and bushier facial hair. By the time of his unexpectedly early death in 1870, however, the size and quality of Dickens's beard had been well and truly overtaken by those of many of his contemporaries. An unwitting pogonotrophical feud would resurface in the twenty-first century, when the £10 note bearing Dickens's image was scrapped by the Bank of England in favour of one showing the naturalist Charles Darwin. It transpired that evolution had played a part in Darwin's beard beating Dickens's: the scientist was more hirsute than the author, so his beard was deemed more difficult to forge.

Charles Dickens by John and Charles Watkins, 1860s

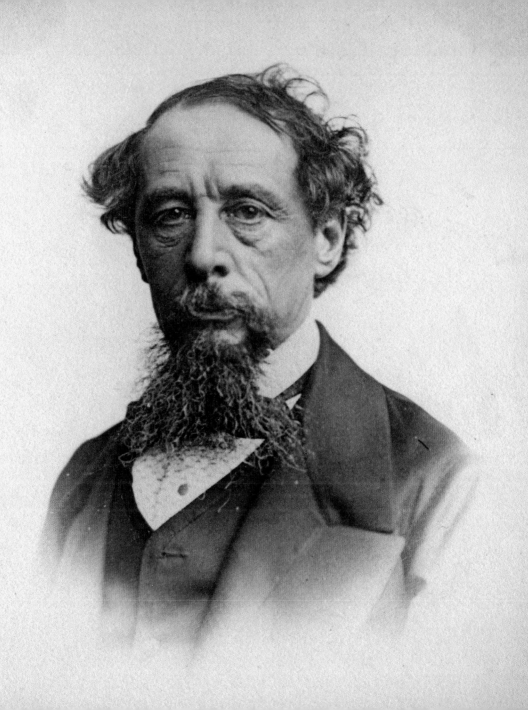

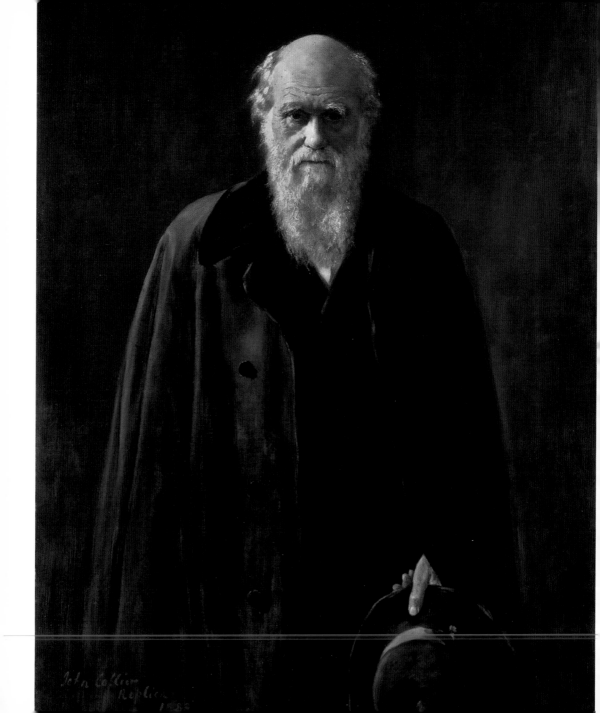

Several of Dickens's friends and colleagues embraced the new era of facial hair with as much fervour as he did. Among them were the illustrators George Cruikshank and John Leech, the novelist Wilkie Collins, and the historian and author Thomas Carlyle. Cruikshank had worked with Dickens on *Sketches by Boz* (1836–7), before going on to illustrate *Oliver Twist* (1837–8). Cruikshank grew prodigious mutton-chop whiskers that curled under his chin, although he chose not to have a beard. In a series of photographs taken in the 1860s at the studio of John and Charles Watkins, Cruikshank can be seen sporting not only his remarkable whiskers but also a startlingly obvious 'comb over', with one long section of hair brought from the back of his head over to his forehead, as the illustrator attempted to pretend he could still grow hair on the crown of his head.

John Leech was famed for his cartoons in the humorous periodical *Punch* and today is best known for his illustrations of the first edition of *A Christmas Carol* (1843). Leech's facial hair curled all around the edges of his face and far on to his neck, but his face itself was kept remarkably hair-free.

John Leech by Sir Joseph Edgar Boehm, c.1865

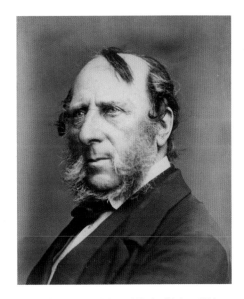

George Cruikshank by John and Charles Watkins, 1860s

Charles Darwin by John Collier, 1883 (artist's copy of his 1881 original)

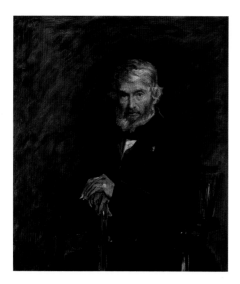

Thomas Carlyle by Sir John Everett Millais, 1877 (detail)

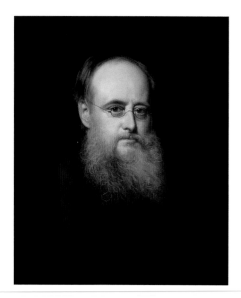

Wilkie Collins by Rudolf Lehmann, 1880

Thomas Carlyle was the author of *The French Revolution: A History* (1837), a veritable tome, which Dickens used as the inspiration for *A Tale of Two Cities* (1859). As a young man, Carlyle's face was clean-shaven. In a series of photographs from 1851, he can be seen with a face a barber's chair would be proud of. By the 1860s, though, he had grown a fashionable full set of facial hair: whiskers, moustache and beard.

Wilkie Collins was a surprisingly unVictorian Victorian. In his popular novels he seemed to espouse conventional family values, yet he chose to live an unconventional lifestyle. He had simultaneous relationships with two women, and supported two families, but never married as he didn't agree with the legal concept of marriage. He was born into an artistic family: his father, William, was a famous landscape painter, and his younger brother, Charles Allston Collins, was a Pre-Raphaelite artist (and a son-in-law of Charles Dickens). Wilkie Collins originally trained as a lawyer, but abandoned the legal profession for writing. His novels include *The Moonstone* – one of the earliest detective novels; *The Woman in White* – a sensational mystery, and the unusual *Heart and Science* – in which his villain is a vivisectionist. When Collins was painted by Sir John

Everett Millais in 1850, he had a mere suggestion of sideburns. By the early 1860s, photographs show him with magnificent whiskers that join forces with his full beard and moustache.

In the early 1850s, a young Indian prince named Duleep Singh was sent to live in England. He had been appointed ruler of the Sikh Empire at the age of five, but as four of his relations had already been assassinated, it was deemed expedient to keep him away from danger; so at the age of 15 he arrived in London. Portraits of the exotic exiled prince became popular attractions, and he duly became a celebrity (Queen Victoria was among his admirers). He was painted in 1854 by one of the Queen's favourite artists, Franz Xaver Winterhalter, who depicted him as a warrior king with sword in hand, a bejewelled turban and closely trimmed facial hair that highlights his features. A later image of him, a caricature by Carlo Pellegrini for an 1882 issue of the magazine *Vanity Fair*, shows him in side profile without a beard, but with thick, carefully sculpted mutton-chop whiskers: a man of London fashion.

'Mr. Le Frank's plump cheeks were, in colour, of the obtrusively florid sort. The relics of yellow hair, still adhering to the sides of his head, looked as silkily frail as spun glass. His noble beard made amends for his untimely baldness. The glossy glory of it exhaled delicious perfumes; the keenest eyes might have tried in vain to discover a hair that was out of place.'

Wilkie Collins, *Heart and Science*, 1883

One artist who documented the changing ideals of facial hair throughout the 1850s was Stephen Pearce. Those who sat for his painting *The Arctic Council Planning a Search for Sir John Franklin* display only a few whiskers and neck beards, but the majority are clean-shaven. The fashion for beards was starting to creep in – by means of whiskers growing longer – but at the date of

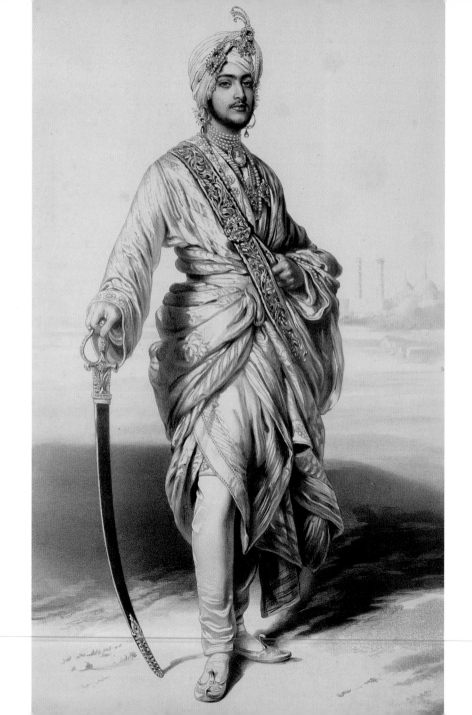

this portrait (about 1851) facial hair was not yet universally accepted. In 1853, Pearce painted a portrait of William Penny, a whaler and Arctic explorer, with no sign of a beard, but with a face framed by enormous whiskers that meet beneath his chin like a chinstrap. Arctic explorers might have been expected to grow as much facial hair as possible to keep out the cold, yet Pearce's 1859 portrait of the intrepid Sir Leopold McClintock shows a man whose whiskers spread right across his cheeks to his ears, but who chose not to grow a beard. By the time of this portrait, the beard was well and truly back in fashion – and it was all thanks to military conflict.

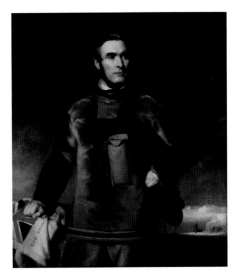

William Penny by Stephen Pearce, 1853

How the Crimean War Changed the Face of Britain

The Crimean War marked the beginning of the most prolific age of facial hair that Britain had seen for centuries. The War, which began for Britain in 1854, was fought in a climate that was often bitterly cold, meaning that many of the soldiers craved as much facial hair as possible to keep their faces from freezing. Even when the seasons grew warmer, many of the soldiers were unable to shave because of the difficulty and expense of getting

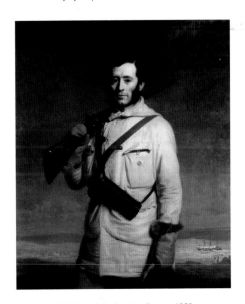

Sir Leopold McClintock by Stephen Pearce, 1859

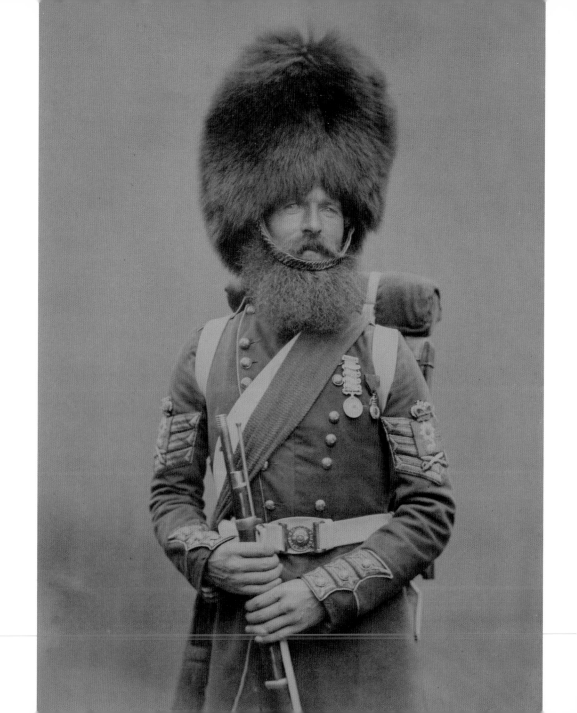

hold of razors and shaving soap. Until this time, military regulations had been very strict about shaving, but during the Crimean War, the rules were relaxed. As a result, many British soldiers grew facial hair that was quite extraordinary in length – so much so that they must have been unrecognisable to their families on their return home.

One of the foremost commanders of the war, and one of those who – in the words of the poet Alfred, Lord Tennyson – had 'blundered' during the notorious Charge of the Light Brigade, was General James Thomas Brudenell, 7th Earl of Cardigan. After his return from the Crimea, his portrait by Henry Wyndham Phillips was published as a print and sold to those who admired him as a victorious military hero. The Earl has an impressive array of long, wavy sideburns and a large moustache, the tips of which are waxed and curled up at the ends. It is difficult to distinguish where the curling sideburns end and the Earl's fur collar begins.

By the time the Crimean War came to an end in 1856, the face of British men had changed irrevocably. As regiments of heavily bearded men began to be sent home, the beard became recognised as the sign of a hero. Before the War, beards had tended to signify that the wearer was overtly religious, or a working-class labourer, or a tramp or a lunatic. After the War, beards were considered the height

'The Kiss in the Railway Train'

A popular music-hall song from the 1860s, 'The Kiss in the Railway Train' tells the story of a young woman who meets a man in a train carriage and is instantly attracted by his moustache. When the train goes into a tunnel he kisses her, but any notions of romance are dashed when it becomes clear that he is actually a thief employing his dastardly moustache to get her attention so he can distract and rob her.

Colour Sergeant 'Willie' McGregor of the Scots Fusilier Guards, photographed in 1856 (after the Crimean War) by Joseph Cundall and Robert Howlett, wearing the post-war tunic but with his Crimean beard

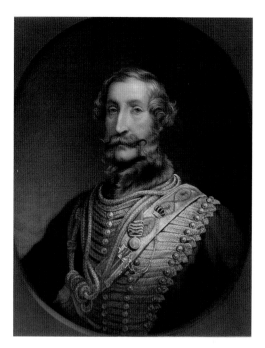

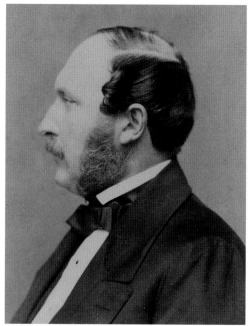

James Thomas Brudenell, 7th Earl of Cardigan, in a print published in 1856 after a portrait by Henry Wyndham Phillips

Prince Albert of Saxe-Coburg-Gotha by John Jabez Edwin Mayall, 1860

of masculinity. Remarkably rapidly, British men laid down their razors and abandoned their barbers in favour of growing facial hair as bushy and manly as that on the faces of returned soldiers. Within a decade, those men who did not – or could not – grow a beard, or at least substantial whiskers, were beginning to be viewed with something akin to suspicion.

Another factor in the sudden sprouting of copious amounts of facial hair was a different threat to the security of British men. This time it was not a war in foreign parts, but a battle on home soil: women had begun agitating seriously for equal rights. As the

suffrage movement gathered pace in the late 1850s and early 1860s, it truly seemed – for a glorious, if short-lived, time – that women would at last become enfranchised. The louder the women's voices and the stronger their arguments for equality, the thicker became the beards of British men and the more intransigent their opposition. Beards, whiskers and bristling moustaches were a viscerally visual representation of the idea that this was *one* thing that women would never be able to do. From the end of the Crimean War until the very end of the nineteenth century, huge facial hair would dominate British men's appearance.

One man who never participated in the pogonophilia of his time was Queen Victoria's husband. Prince Albert, who was constantly in the public eye until his untimely death in 1861, famously kept his chin hair-free. The portraits of him from the 1850s could be mistaken as belonging to someone from an earlier age, as he consciously kept the style of facial hair that he had worn at the start of his marriage. While all around him men were sprouting enormous beards, Albert kept to his trademark whiskers and neat moustache – although the whiskers crept further and further down towards his chin as the decade progressed.

Dundrearies, Piccadilly Weepers and Artistic Facial Hair

In 1861 a new word came into usage in Britain. Tom Taylor's play *Our American Cousin* had its London premiere that year, and one of the characters, Lord Dundreary, was a comic fop with

prodigious whiskers. As whiskers had been growing in popularity once again, they now became known as 'dundrearies'. (It was during a performance of *Our American Cousin* in 1865 that US President Abraham Lincoln was assassinated.)

There have been various other nicknames for whiskers. Some referred to them as 'Piccadilly weepers' because they

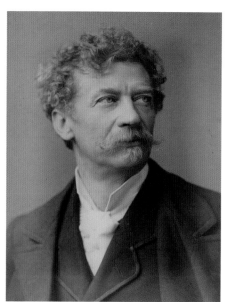

were worn by the kind of dandy who could be seen in London's Piccadilly. During the American Civil War, the word 'sideburns' also came into common use, inspired by the bushy moustache of Major General Ambrose Burnside, which had been allowed to connect with his whiskers and formed an impressively thick and unbroken line of hair right across his face. The term 'mutton chop' was also common parlance, used to describe the type of whiskers that were roughly triangular, rather like the shape of a meat chop.

One of the most famous artists in late Victorian England was the sculptor Sir Joseph Edgar Boehm, who immortalised the faces (and facial hair) of many famous contemporaries.

Sir Joseph Edgar Boehm by Elliott & Fry, c.1887–90

He was the secret lover of Princess Louise (sixth child of Queen Victoria and Prince Albert) and was made the Queen's Sculptor-in-Ordinary in 1881. Boehm, who was a prominent member of the Aesthetic circle devoted to 'art for art's sake', can be seen as beard- and sideburn-free, although he sports a large, drooping moustache. In a series of images

FACIAL HAIR AND FEMINISM

It is fascinating to note how often a surge in men's desire to grow facial hair has coincided with their feeling threatened by female power. Two of the most heavily bearded eras in British history were during the reigns of Queen Elizabeth I and Queen Victoria. In the mid-nineteenth century, in addition to having a female monarch, Victorian men felt besieged by women agitating for more political power and daring to ask for the vote. By the time all adult British women were finally granted the vote in 1928, the mirrors of Britain were reflecting men admiring their manly moustaches. In the 1960s and 1970s, as 'women's liberation' gained new ground, facial hair sprouted to an extent that hadn't been seen since the reign of Queen Victoria. In the 2010s, as the topic of feminism was once more widely discussed in the press, the huge 'hipster' beard began to flourish.

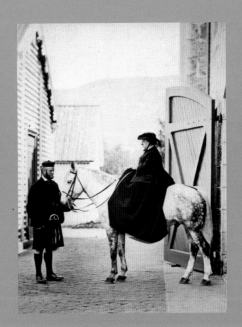

Queen Victoria and her gillie. John Brown. by W. & D. Downey. 1868

taken at the fashionable photographic studio of Elliott & Fry, Boehm can be seen sporting a small beard, something in between a soul patch (a small triangle of hair just below the lower lip) and a goatee, but he chooses never to be recorded with a full Victorian face of hair. Boehm may have eschewed the beard for himself, but he is the creator of the some of the Gallery's most magnificent specimens of beards and whiskers.

Among the many fine examples of Victorian facial hair that Boehm sculpted are those belonging to Charles Darwin, Lord Tennyson, John Leech, Sir Henry Cole (a friend of Prince Albert, one of the creators of the Great Exhibition of 1851 and the first director of the V&A), the soldier, novelist and poet George John Whyte-Melville, the political agitator and statesman John Bright – whose whiskers look like fingers caressing his chin – and the writer and art critic John Ruskin, whose whiskers contrast perfectly with the rest of his clean-shaven face and mark him out as an old-fashioned buffer, a man not moving with the times.

Artists including Frederic Leighton and Sir John Everett

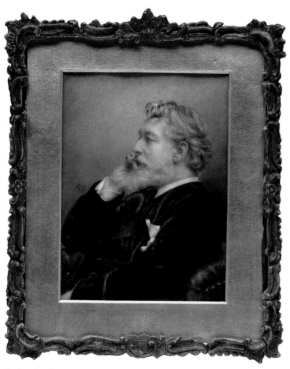

Frederic Leighton,
Baron Leighton, by
Rosa Carter, 1896

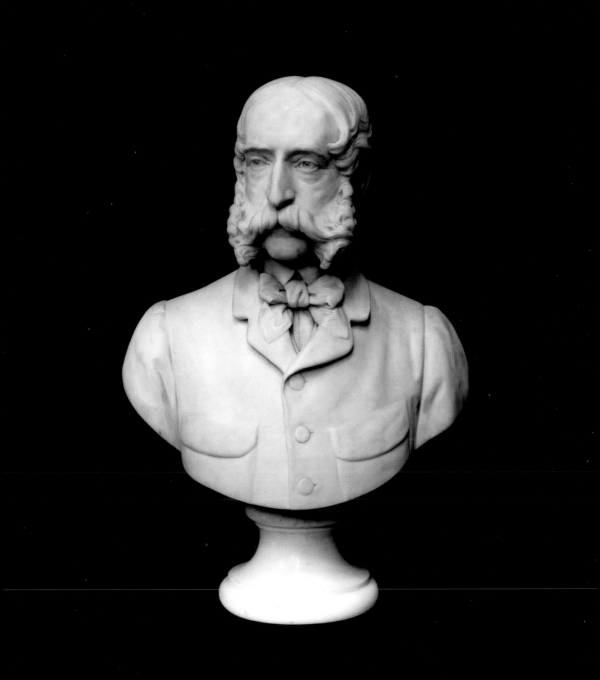

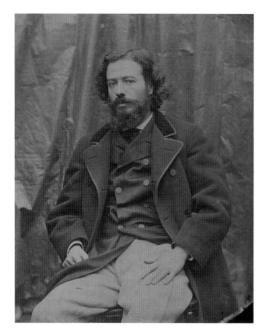 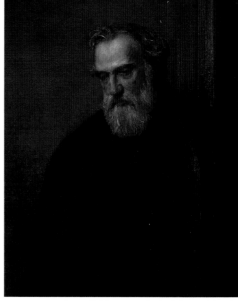

Alphonse Legros by Charles Lutwidge Dodgson, 1863

Alphonse Legros by Charles Haslewood Shannon, 1899 (detail)

Millais embraced the chance to wear bohemian facial hair. The French artist Alphonse Legros arrived in London in 1863 and was appointed professor of fine art at the Slade School of Art. He was photographed that year by Charles Lutwidge Dodgson (aka Lewis Carroll), looking at ease with full facial hair and flowing locks. In older age, in 1899, he was painted by Charles Haslewood Shannon, with shorter hair but still with a large beard and moustache.

Dodgson also photographed the Pre-Raphaelite Dante Gabriel Rossetti in 1863, the year after the artist's wife Lizzie

committed suicide. He is no longer the handsome, carefree young idealist of his 1847 self-portrait, with long wavy hair and a boyish face with no hint of a beard. In Dodgson's photograph Rossetti looks world-weary. A few years later, around 1871, Rossetti and his facial hair were painted by the eminent George Frederic (G.F.) Watts. It is a sympathetic portrait of a man at a very difficult time, who looks older than his years. He was in a troubled relationship with Janey Morris, who had become his muse after Lizzie's death, but who was also married to his great friend William Morris.

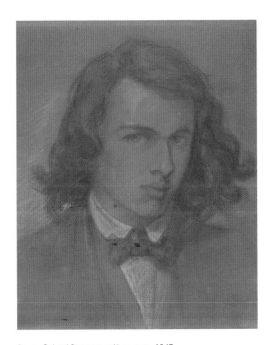

Dante Gabriel Rossetti, self-portrait, 1847

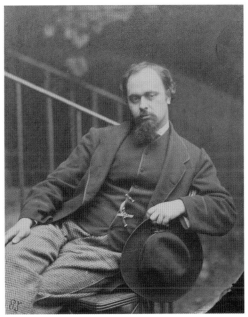

Dante Gabriel Rossetti by Charles Lutwidge Dodgson, 1863

Dante Gabriel Rossetti by George Frederic Watts, c.1871

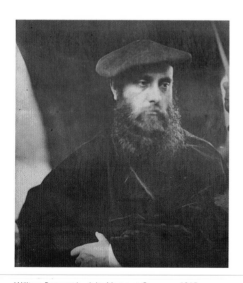

William Rossetti by Julia Margaret Cameron, 1865

In 1872, following a bout of severe depression, Rossetti tried to kill himself. It was ten years after the suicide of his wife and, like her, he swallowed a bottle of laudanum. His breakdown had been exacerbated by the critic Robert Buchanan's vicious article 'The Fleshly School of Poetry' (written under a pseudonym), in which he slated Rossetti's poetry. To make matters worse, Rossetti had retrieved the poems by great stealth from Lizzie's exhumed coffin, where he had placed them in 1862.

Dante's younger brother, William Rossetti, who had joined his sibling in the Pre-Raphaelite Brotherhood, was always in awe of the six artists in the group. Although desperate to emulate them, William was destined merely to chronicle their activities instead. He had also been forced to give up his initial ambition of becoming a doctor when his father became ill and someone had support the family. Dante refused to give up his art (he had not yet found the success that was to come), so William left school and took a job in the tax office. Despite his day job as a civil servant and his evening job of chronicling the Brotherhood, William still harboured dreams of being recognised as an artist and cultivated a huge beard to match those of his bohemian friends. Indeed, the photographer Julia Margaret

'Walt Whitman closes his eyes. He is a small man and his beard
is ludicrous on the reservation, absolutely insane.
His beard makes the Indian boys righteously laugh. His beard
frightens the smallest Indian boys. His beard tickles the skin
of the Indian boys who dribble past him. His beard, his beard!'

Sherman Alexie, from 'Defending Walt Whitman', 1996

Cameron posed him as an artist, denoted by
his wearing a beret. William's greatest achieve-
ment, however, was probably bringing the work
of another exuberantly bearded writer to Britain
– the American Walt Whitman. He had become
captivated by his poetry after receiving a copy of
Leaves of Grass in 1855. William Rossetti worked
tirelessly to promote Whitman, editing and pub-
lishing a new edition of his poems.

The Rossettis' great friend Algernon Charles
Swinburne, a scandalous poet, was famous for
his bright copper-coloured facial hair. His Aes-
thetic-style moustache and neatly shaped beard
were painted by G.F. Watts in 1867 and immor-
talised by the cartoonist Carlo Pellegrini (also
known by his pseudonym of 'Ape') in 1874. In
a 1900 chalk portrait of an ageing Swinburne,
however, Sir Robert Ponsonby Staples depicts
a man whose facial hair appears to have taken
over as his hairline and his Aestheticism have

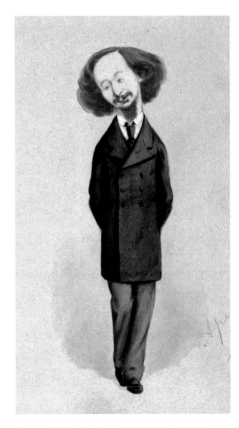

Algernon Charles Swinburne by Carlo Pellegrini, 1874

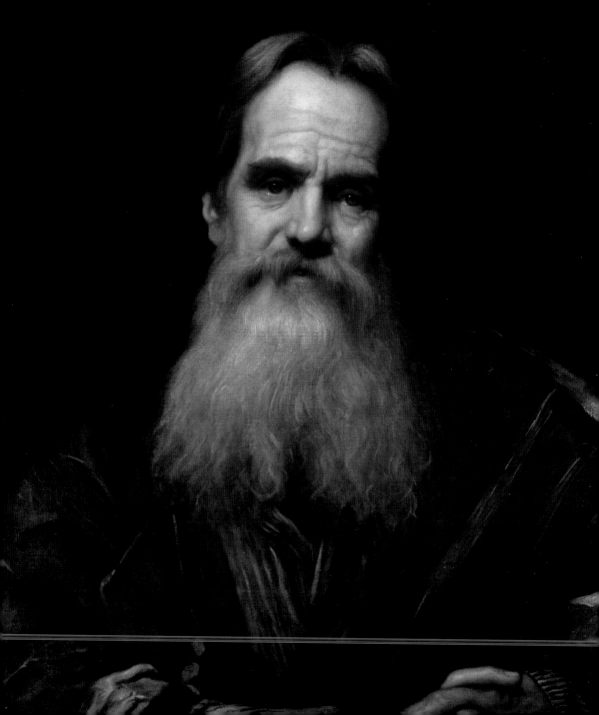

receded. Swinburne's mouth is now completely invisible, lost inside the wiry mass of beard and moustache.

Another Pre-Raphaelite Brother was William Holman Hunt, who at the start of his career was fresh-faced and very conventional, a man in awe of his more flamboyant friends. By the time he had become one of Britain's wealthiest artists, he had adopted the archetypal appearance of a bohemian, wearing Middle Eastern robes and keeping his enormous beard long after most of his friends had returned to the barber's chair. In 1900 he was painted by his friend Sir William Blake Richmond, and his grey, woolly facial hair dominates the centre of the canvas.

An artist who was closely allied to the Pre-Raphaelites was the aforementioned painter and sculptor G.F. Watts. In addition to immortalising the facial hair of his friends William Morris, Frederic Leighton, Algernon Swinburne and others, Watts himself grew a superb set of whiskers, moustache and full beard – and enjoyed how much his unkempt appearance annoyed the fashionable elite. In the mid-1850s, when other men were only just beginning to let their chin hairs appear, Watts was photographed by James Soame wearing a full-length smock, rather like

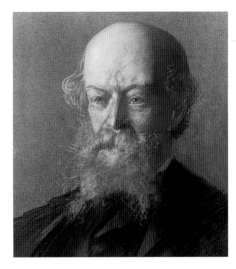

Algernon Charles Swinburne by Sir Robert Ponsonby Staples, 1900 (detail)

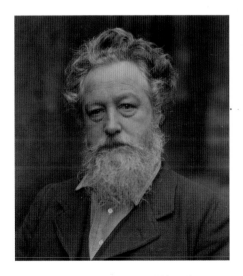

William Morris by Sir Emery Walker, 1889 (detail)

William Holman Hunt by Sir William Blake Richmond, 1900

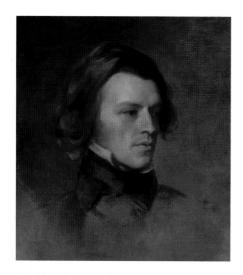

Alfred, Lord Tennyson by Samuel Laurence and
Sir Edward Coley Burne-Jones, c.1840

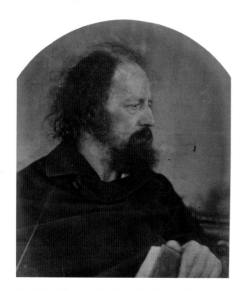

Alfred, Lord Tennyson (the 'Dirty Monk' portrait)
by Julia Margaret Cameron, 1865

a monk's habit, with his bare feet visible beneath the hem and unruly facial hair cascading on to his chest.

Images of the poet Alfred, Lord Tennyson perfectly illustrate the changing face of the Victorian man. His portrait of about 1840 by Samuel Laurence (completed by Sir Edward Coley Burne-Jones) shows a dashingly handsome Romantic poet with a mere hint of whiskers on an otherwise clean-shaven face, allowing the artist to focus on the poet's perfectly formed lips. An even closer shave was captured in Thomas Woolner's plaster medallion of the poet. (Woolner was one of the founders of the Pre-Raphaelite Brotherhood, and Tennyson was one of the Brotherhood's heroes, having made it on to their list of 'immortals'.) When looking at these early images, it is astonishing that this Tennyson is the same man who appears so heavily bearded in photographs by James Mudd, John Jabez Edwin Mayall, Elliott & Fry and others. The photographer Julia Margaret Cameron, who was Tennyson's neighbour on the Isle of Wight, took a series of photographs of him. One iconic image famously led Tennyson to describe himself, with approbation, as a 'dirty monk'. The bearded Tennyson was also painted by G.F. Watts, and in 1873 Thomas Woolner sculpted him again, a

George Frederic Watts by James Soame, mid-1850s

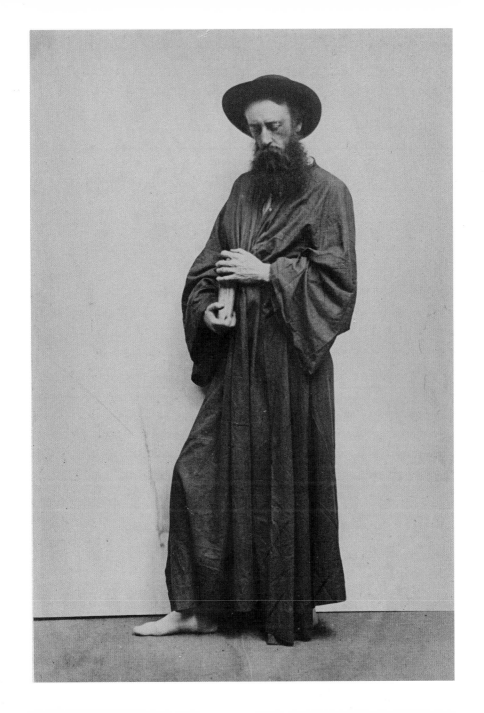

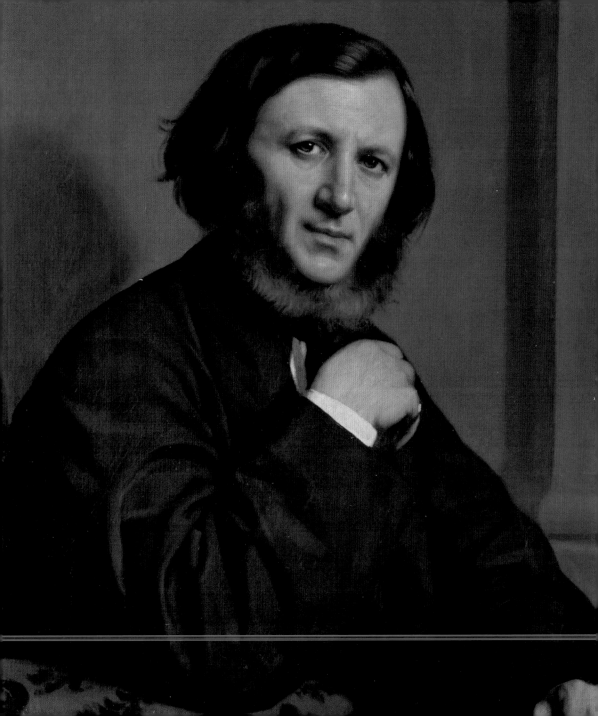

marked contrast to his appearance on the earlier medallion. All these later images show Tennyson with an unruly full beard, which was allowed to roam more and more freely with each passing year.

Tennyson's fellow poet and contemporary Robert Browning had his unusual facial hair recorded by the Italian artist Michele Gordigiani. (Despite being one of the most popular writers in Victorian Britain, Browning chose to live in Italy, having eloped there with fellow poet Elizabeth Barrett.) Gordigiani's portrait, painted in Florence, where the Brownings had settled, clearly shows the poet's neck beard – billowing facial hair that began underneath the chin – while the rest of his face was clean-shaven. Another artist who documented the facial-hair fad of the 1800s was Sir George Scharf, the first director of the National Portrait Gallery. His sketchbooks are filled with images of himself and his friends sporting different styles of facial hair.

Among the most copiously bearded men of his generation was the Irish playwright George Bernard Shaw, who became one of the most famous faces in London. Shaw's facial hair was so well known that he could be recognised just in silhouette. One story claims that an eager advertising executive from a razor company hit upon the publicity stunt

Edward Lear

The English artist, author and poet Edward Lear, who himself sported a fulsome beard, included the following poem in his *A Book of Nonsense* (1846):

There was an Old Man with a beard,
Who said: 'It is just as I feared! –
Two Owls and a Hen, four Larks and a Wren
Have all built their nests in my beard.'

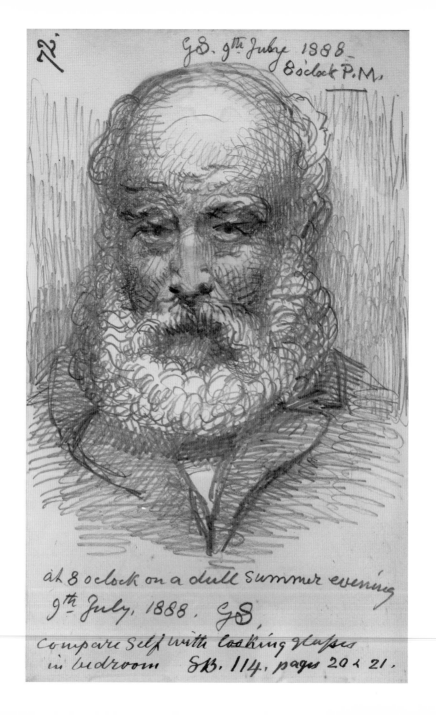

of persuading Shaw to shave off his beard. The writer is said to have responded with a perfectly composed postcard of refusal:

Gentlemen:

I shall never shave, for the same reason that I started a beard, and for the reason my father started his. I remember standing at his side, when I was five, while he was shaving for the last time. 'Father,' I asked, 'why do you shave?' He stood there for a full minute and finally looked down at me. 'Why the hell do I?' he said. He never did again.

George Bernard Shaw by Sir Emery Walker, 1888

Shaw's beard was not appreciated by everyone else as much as it was by himself. In later years the early Hollywood star William Haines met the playwright and commented, 'I thought he was a horrible-looking old man ... he needed a shave.' In 1950, Shaw's beard made the news again. By this time he was 94 years old and had been in hospital, where a doctor had requested his beard be shaved off for infection control. Shaw refused. He also refused a daily bath, purportedly telling the nurses, 'Too much washing is not good for antiques.'

Sir George Scharf, the first director of the National Portrait Gallery, in a self-portrait from one of his many sketch-books, dated 9 July 1888

WOMEN AND FACIAL HAIR, 2

A special place in history has to be reserved for the 'bearded lady', such a beloved feature of Victorian circuses and freak shows. The Wellcome Library in London has a collection of associated memorabilia and notes suggesting that while many of the sideshow women are believed to have worn fake facial hair, others may have been suffering from a rare condition known as congenital generalised hypertrichosis terminalis (CGHT), unfairly nicknamed 'werewolf syndrome'. In the 1880s collectors and fetishists could buy postcards of the 18-year-old American Annie Jones (c.1860–1902), one of the most famous bearded ladies. In one iconic series of photographs she is pictured lying provocatively on a chaise longue wearing sexy [Victorian] underwear and a full beard and whiskers. The hair on her head was also luxuriantly thick and long, reaching almost to the ground. Virginia-born Annie had first appeared as an act in Barnum's circus while still a baby. Her parents claimed that she had been born with a thick covering

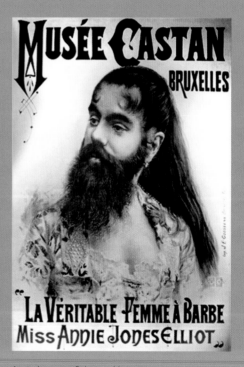

Annie Jones in a Belgian publicity poster

of hair and a full beard. From the earliest months of her life she was exhibited as a circus freak known as 'the infant Esau'.

The age of photography allowed a far wider audience to discover the phenomenon of female facial hair. Madame Delait (1865–1939), the bearded lady of Plombières, was a brilliant publicist and made part of her income by selling signed postcards of herself. Some of the most notable images of Madame Delait date from the 1920s; head-and-shoulder shots, in which her beard can be closely examined.

Yet all other bearded women were upstaged by a Hungarian aristocrat who began to grow a beard at the age of 19, shortly after giving birth to an unusually tiny son. The Baroness Sidonia de Barcsy (1866–1925) did not grow merely a few wisps of hair, but a full, chestnut-coloured beard. Following an economic crisis in Budapest, the formerly wealthy baron (who was immensely tall and well muscled), the bearded baroness and their dwarf son left Hungary and joined a circus. They travelled around Europe and North America becoming fêted and famous. On her visiting card the baroness proudly proclaimed the dubious honour that she had been named 'The Queen of Freaks' and had received 'The Cross of Honor from the professors of the universities' (no specific university was mentioned).

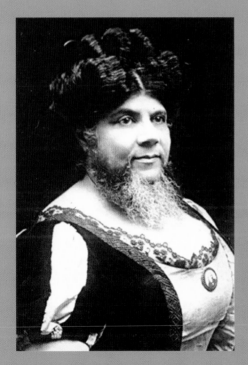

Baroness Sidonia de Barcsy by an unknown photographer

The Aesthetic Face

By the late 1860s, with the fashion for beards refusing to come to an end, Britain's barbers were in trouble. Having no one to shave, they had to look for other ways to make money, so they started to sell grooming products designed specifically for moustaches, whiskers and beards. The Wellcome Collection contains a series of advertisements from the 1870s to the 1890s for Buckingham's Dye for the Whiskers. These claim that the dye will not only make a beard appear more luxuriant and its wearer more youthful, but that it can also 'cure' beard dandruff, eruptions and itching.

As the nineteenth century headed into its final two decades and the Aesthetic movement began to take hold, many people had begun to look back longingly to a time before the Crimean War, when men's faces did not all look identically hirsute. The fashion for facial hair was changing and, just as they had in the classical world, differing styles were now denoting a difference between generations. As the Aesthetic young man began to break away from tradition and shave his face, the older generation spluttered dire warnings. In 1880 a book entitled *The Philosophy of Beards* was published, warning that the Empire's moral code was being eroded by newfangled ideas and concluding that 'the absence of [a] beard is usually a sign of

An American advertisement for facial-hair dye, showing how Buckingham's Dye can transform greying whiskers

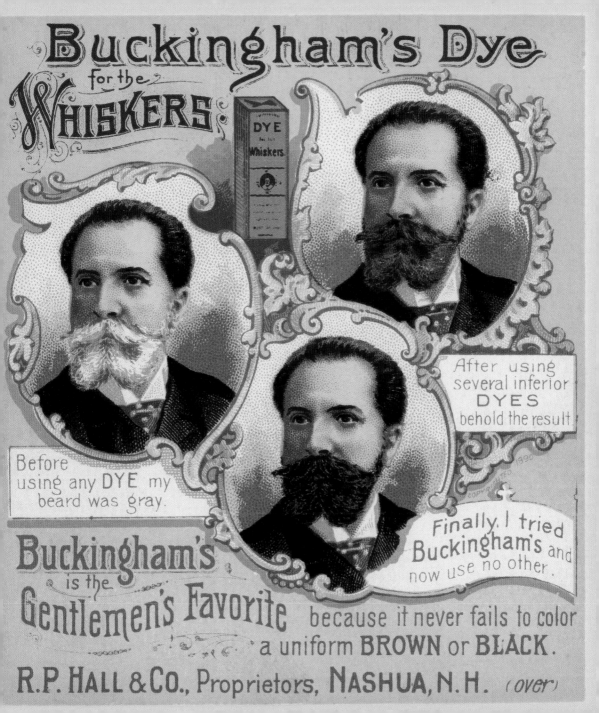

physical and moral weakness'. The underlying fear was that a clean-shaven man was latently homosexual – a criminal offence in Queen Victoria's Britain.

Despite these warnings, young men were returning to the joys of a daily shave, often leaving a small goatee and moustache, or choosing to sport a clean-shaven face except for a rakishly hirsute upper lip. From the 1880s onwards a popular pastime among university undergraduates was 'beaver spotting', said to have originated at Oxford. The game involved seeking out a man who was unfashionable enough to persist in wearing a huge beard and whiskers and to yell 'Beaver!' in a derisory fashion. It was alleged that Prince George (later King George V) was hollered at by a London taxi driver, who leant out of his cab and yelled 'Beaver' at the unrecognised man in front of him. A classic example of an outmoded 'beaver' can be seen in the 1879 self-portrait by Charles West Cope. Cope was predominantly a history painter and had gained fame in the 1840s after winning a prize to decorate the Houses of Parliament. In his self-portrait he looks out sideways at the viewer, and every hair in his full-face beard and moustache has been meticulously recorded. The portrait seems reminiscent of those painted in the High Renaissance, but with distinctly Victorian colour and brushwork.

Victorian politicians were not immune to the lure of the beard, as can be seen in the magnificently bearded bust of Irish MP Charles

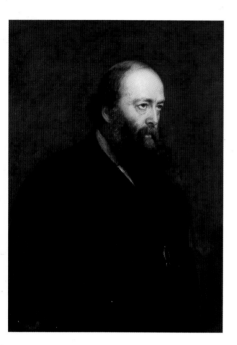

Robert Gascoyne-Cecil, 3rd Marquess of Salisbury, by Sir John Everett Millais, 1883 (detail)

Charles West Cope, self-portrait, 1879

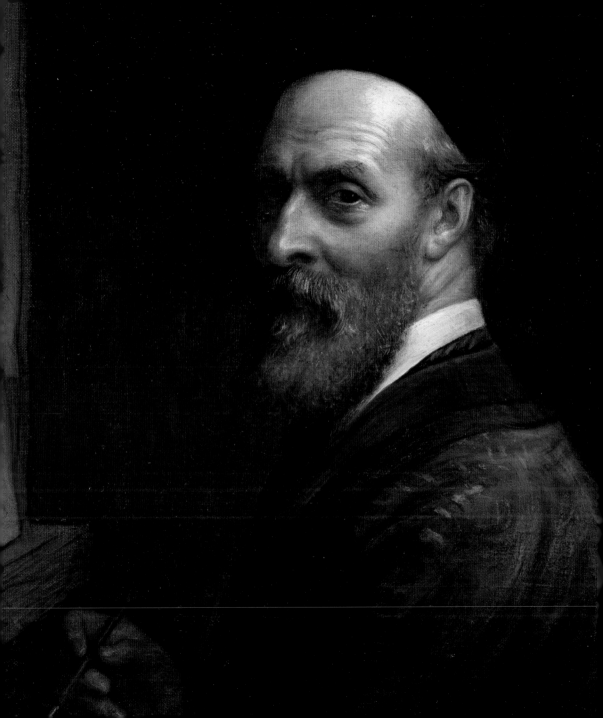

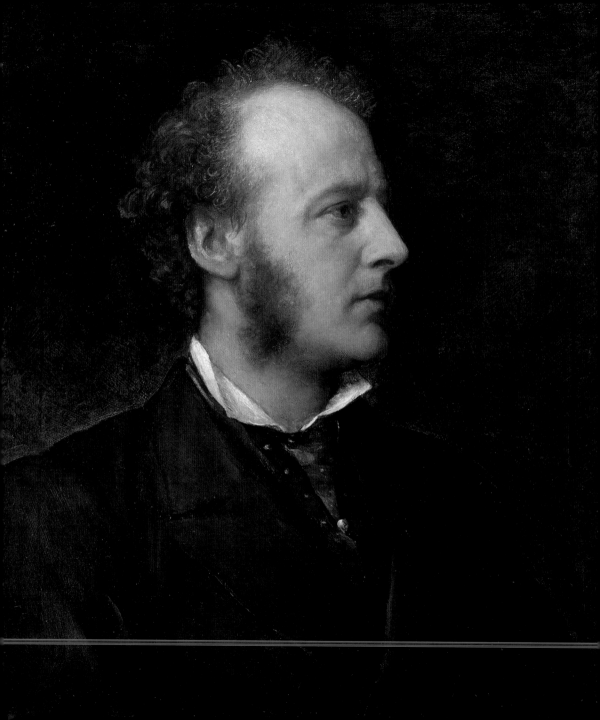

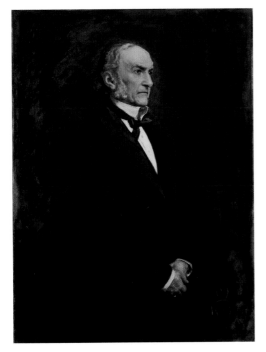

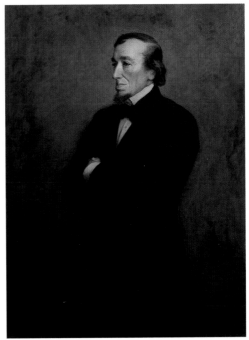

William Ewart Gladstone by Sir John Everett Millais. 1879

Benjamin Disraeli by Sir John Everett Millais. 1881

Stewart Parnell sculpted by Mary Grant in 1892, and in Sir John Everett Millais' 1883 portrait of the future Prime Minister Robert Gascoyne-Cecil, whose exuberant facial hair contrasts with his gleaming bald pate, highlighted by the artist as if spotlit. Millais also painted the prime-ministerial rivals William Ewart Gladstone and Benjamin Disraeli, in 1879 and 1881 respectively. When looked at side by side, these two men appeared to have made a conscious decision to wear exactly opposite styles of facial hair. Gladstone's cheeks are heavily whiskered but his chin is hair-free, while Disraeli is clean-shaven except for a dandified pointy beard on the tip of his chin, a

Victorian version of a Van Dyck. Millais himself chose to emulate Gladstone's style, eschewing a beard in favour of bristling whiskers.

For the vast majority of Victorian women, especially those born after 1854, seeing a man without facial hair was a rarity, and even something of a shock. It was said that many a Victorian woman had no idea what a man's face would look like without hair, and that when the fashion for shaving returned, they were appalled to see podgy cheeks, heavy jowls and wrinkled lips. Meanwhile, the Church of England was once more in dispute about hairy faces. In 1893 the *Star* newspaper reported: 'The Bishop of Winchester has declared war against the clerical moustache.'

Ranjitsinhji ('Ranji') Vibhaji, Maharaja Jam Sahib of Navanagar, by Reinhold Thiele, late 1890s

The Rise of the Moustache

That moustaches were gaining in popularity was apparent not only in the pulpits but also on sports pitches. In the 1890s, the popular cricketer Prince Ranji (later the Maharaja Jam Sahib of Navanagar) was photographed regularly and could be seen sporting a highly fashionable moustache but no other facial hair. This was the sign of the new type of dandy, for whom the cricketing prince was a hero. A sporting contemporary of Prince Ranji was the Welsh rugby star Arthur Gould, who also took pride in his bristling moustache on an otherwise clean-shaven face. Both men are in stark contrast to one of the most famous of all Victorian sporting heroes, W.G. Grace. He was the first English cricket player

W.G. Grace, attributed to Archibald John Stuart Wortley, 1890

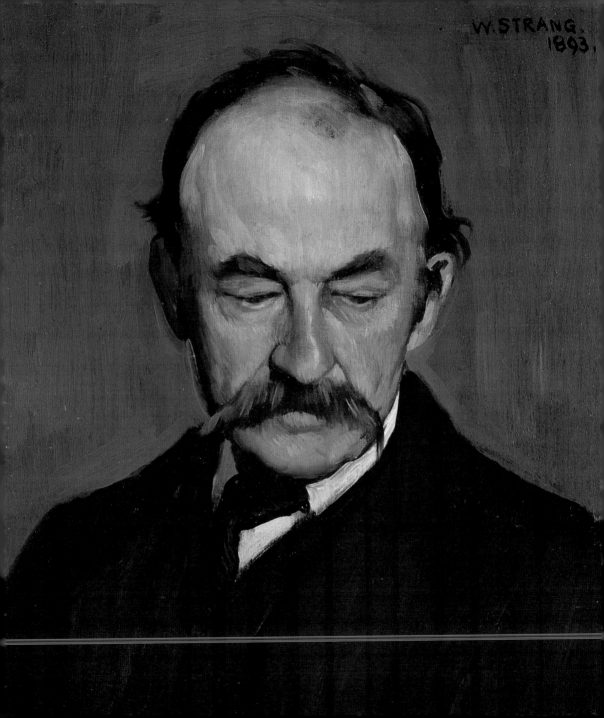

W.STRANG.
1893.

to hit a Test century, and the first to reach the coveted 'double' – 1,000 runs and 100 wickets in a single season. In his 1890 portrait, attributed to Archibald John Stuart Wortley, little of Grace's face is visible between his cricketing cap and his facial hair.

The novelist Thomas Hardy was painted in 1893 exhibiting a moustache that Prince Ranji would have been proud to stand alongside. Hardy, then 53 years old, had embraced the new style of going beardless, which was favoured mostly by the younger generation.

Of course, not every man could afford to attend the barber for a daily shave; in 1893 a Belfast hairdresser, B. Ranagan's, reported that it was the fashion among working men to have a shave once a week on a Saturday, after being paid on a Friday. The palaver of shaving was about to become much easier and cheaper thanks to the American inventor King Camp Gillette. In 1895 he came up with the idea of a safety razor with a disposable blade. It took six years – and much pain – to perfect his invention, but in 1901 he managed to persuade others to try it out. The disposable razor blade was an instant hit, and the patent was granted in 1904. Gillette's invention spawned a multi-million-dollar industry for the company that still bears his name.

> **'Never put anything on paper, my boy, and never trust a man with a small black moustache.'**
>
> P.G. Wodehouse, *Cocktail Time*, 1958

By the turn of the twentieth century, beards were worn mostly by grumpy older men, and in 1904 the writer and humorist Frank Richardson coined the expression 'face fungus'. Although he is little read today, Richardson was popular in his lifetime and a major influence on other writers, including P.G. Wodehouse. In Richardson's comic novel *The Man Who Lost His Past* (1903) his

Thomas Hardy by William Strang, 1893

protagonist is a man who has been in a train crash and lost his memory. As he tries to work out who he is, the man looks in a mirror and thinks:

> His whiskers precluded the supposition that he was a member of the Roman Hierarchy, or an eminent actor, or an American jockey. Indeed no such prudent jockey would handicap himself by wearing such windtraps as his whiskers. But, after a lengthy inspection, all the data that he had collected only proved affirmatively that he was a man who wore whiskers, and that he was dissatisfied with his personal appearance.

In a 1905 photograph by Frederic G. Hodsoll, Frank Richardson is shown sporting a thick but carefully constrained moustache.

How Science Scuppered the Beard

Around the same time that Richardson was writing about 'face fungus', beards faced an enemy other than fashion. Scientific advances had been made about bacteria and its role in illness and infection, so new rules of hygiene needed to be imposed. In 1898 new public baths had opened in London, and the St Pancras medical officer's report included the words: 'Repeated bathing and cleansing and more vigorous measures, especially the treatment of the hair and beard, are necessary to obtain riddance of some of the human vermin which occasionally prove most intractable.'

Frank Richardson by Frederic G. Hodsoll, 1905

On 10 May 1902 the *Star* newspaper published an article entitled 'Danger Found in the Beard':

> A movement against the beard has been started ... For some years fashion has favoured the shaven face. Now come the doctors, declaring that the beard is a vehicle for the spread of disease germs, which may not only menace the health of the wearer, but also be transmitted to others; that the dairyman who wears a beard does so to the peril of his customers who drink the milk he contaminates; that doctors who wear beards report greater mortality among their patients than those who do not; that the man with a beard who enters a railway coach cannot come away without an addition of bacteria, which always infests such places.

The fear of bearded dairymen was something that had originated in New York, where the Board of Health banned dairy workers from growing beards. Dr Park, who worked for the board, was quoted as saying:

> There is real menace to the milk if the dairyman is bearded. ... the milker may be diseased himself ... and the dried sputum may accumulate on his beard and drop from it into the milk ... and you have, no doubt, noticed that men with long beards have a habit of stroking them downward. That has the effect of brushing off any germs they may contain ... The beard, particularly when damp, may become an ideal germ-carrier.

The discussion about beards also moved into the medical sphere, where beards were never banned, but the possibility of such a ban was regularly debated. The consensus seemed to be that surgeons should be clean-shaven, although general practitioners did not need to be. One case that made the newspapers was revealed by a whistle-blowing surgeon horrified by the actions of one of his older colleagues. He revealed that the surgeon had refused to tie up his beard, and it had touched the area being operated on, which was otherwise sterile. The young doctor kept an eye on his patient for several days and noted that the places where the beard hairs had touched the wound all became infected.

Another scourge of the day was ringworm, a highly contagious skin infection, which was particularly prevalent among the poorest in the country. In 1904 a London County Council report stated that anyone suffering from 'ringworm of the beard must not be served in the barbers', hairdressers' or haircutting shops'. This clause was seen as even more important than the one banning dogs and cats from hair establishments.

One of the greatest worries among Victorian and Edwardian medical professionals was consumption, now known as tuberculosis, for which there was no cure. New regulations were put

Death by Moustache

On Wednesday, 5 October 1910, the *Western Times* reported the following story:

Which Possessed the Handsomest Moustache?
'A quarrel between two men as to whom possessed the more handsome moustache resulted in the death of Morton Norbury, aged 44, paperhanger, of Scotland-street Sheffield. The jury returned a verdict that the deceased died from the effects of a fractured skull through being pushed over by the other man without felonious intent.'

in place, and in 1906 the medical officer's report stipulated: 'Consumptives should not kiss on the lips. A male consumptive should not wear beard or moustache, but should be clean shaved.'

These types of stories began a whirl of activity in various sectors of society. Great strides forward had been made in the understanding of germs and how to detect them, and there was fervorous testing of people and places to see how infection-ridden they were. Tests were carried out on all types of public building, including hospitals, schools and offices. Seats on trains and trams were swabbed, and the results made for uncomfortable reading. Barbers' shops were swooped upon and all their towels, chairs and equipment tested for hygiene using the latest methods.

In 1907 a French scientist ran an unusual experiment. He approached bearded and beardless men on the streets of Paris and asked each of them to kiss his female assistant. Before each kiss, the woman's lips were cleaned with antiseptic. After each kiss her lips were swabbed and the cultures preserved. At the end of the experiment, the swabs were examined and the scientist published his findings. He claimed that bearded men's kisses contained considerably more bacteria than those from clean-shaven men, and the bacteria was far more varied.

The white-bearded German pathologist and anthropologist Rudolf Virchow observing a cerebral operation at the Sorbonne, Paris, in August 1900, when unguarded facial hair, indeed hair generally, in the operating theatre was clearly still commonplace

FALSE BEARDS

There are few disguises so beloved of crime writers as the false beard. Both Agatha Christie and Sir Arthur Conan-Doyle made prominent use of the device – indeed Sherlock Holmes seldom solves a case without resorting to disguise or uncovering the true identity of someone else lurking beneath fake facial hair. In recent years, a flurry of celebrities have hidden behind false beards: from footballer Paul Gascoigne wearing a Rasputin-style beard to foil the paparazzi, to actor David Hayman who took a 'joke-shop beard' on an aid mission to Afghanistan, where the kidnap of Westerners by the Taliban was an ever-increasing problem.

In 1910, Virginia Woolf was the sole woman in a group of pranksters who decided to disguise themselves as the Prince of Abyssinia and his entourage. The elaborate practical joke involved faking an official telegram to the Royal Navy announcing that the Prince was in England and wanted to see the Navy's flagship vehicle – the *Dreadnought*.

The group of friends, who posed for photographs in a London studio before setting off, wore dark skin make-up, long robes, turbans and false beards, all of which fooled the Navy, and they were shown around the battleship with great ceremony. The following day, the story appeared in the press, leaked by one of the group, Horace Cole. Journalists were enthralled, especially by the idea that a woman in a false beard had fooled the *Dreadnought's* Commander-in-Chief, and Woolf and her friends were besieged with pleas for interviews.

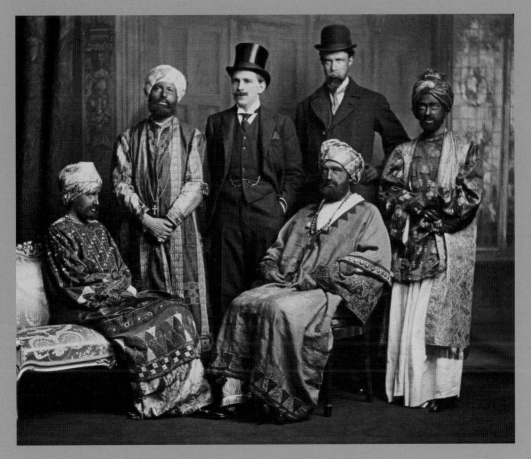

The *Dreadnought* hoaxers, in one of several photographs taken at the Lafayette studios in London on 7 February 1910, shortly before the party set out on the train to Weymouth. Virginia Woolf (then Virginia Stephen) is seated on the left, complete with false beard.

From the First to the Second World War

The death knell for the British beard and whiskers was finally tolled during the First World War when it was discovered that the seals on gas masks would not work on hairy faces. Men could wear moustaches with pride (provided they were in the correct rank of the military to be permitted to do so) if they did not extend to the edge of the face and impede the gas mask's seal. Beards, whiskers and any other extraneous hairs had to be shaved off or they could have proved deadly in a gas attack. In a 1917 photograph of the war artist John Nash along with fourteen soldiers, it is notable that there is not a single man wearing a beard or sideburns, and only one has a (very small) moustache.

After the War, the previous popularity of beards did not return, and it would be many decades before it did so. Moustaches, however, became increasingly popular once young military men returned to civilian life. During the War, it was considered a privilege of rank to grow a moustache, and many of the young

Soldiers, possibly Austrian, wearing gas masks in a trench on the Western Front during the First World War

men who had been forced to shave every day now longed to grow a dashing facial appendage.

In 1920 a young Agatha Christie published her first crime novel, *The Mysterious Affair at Styles*. In it she introduced her now iconic detective, a fastidious Belgian former police officer called Hercule Poirot. His great friend Captain Hastings describes him thus:

> Poirot was an extraordinary looking little man. He was hardly more than five feet, four inches, but carried himself with great dignity. His head was exactly the shape of an egg, and he always perched it a little on one side. His moustache was very stiff and military. Even if everything on his face was covered, the tips of moustache and the pink-tipped nose would be visible. The neatness of his attire was almost incredible.

Since that first novel, Hercule Poirot and his moustache have gained fame across the world.

The moustache had become emblematic of the modern man, and a symbol of the end of wartime constrictions. Every young man was now free to do what he liked with his facial hair, irrespective of commanding officers or the inventors of gas masks. In Hollywood the stage was set for the arrival of dashing stars such as Ronald Colman, Clark Gable and Errol Flynn, who sported a narrow moustache that could make a heroine swoon. As more young men began to grow moustaches, however, antipathy towards facial hair started to rear its head again. In 1932 a reader identified as H.P.S.S. was moved to write to the editor of the *Evening Telegraph* about the

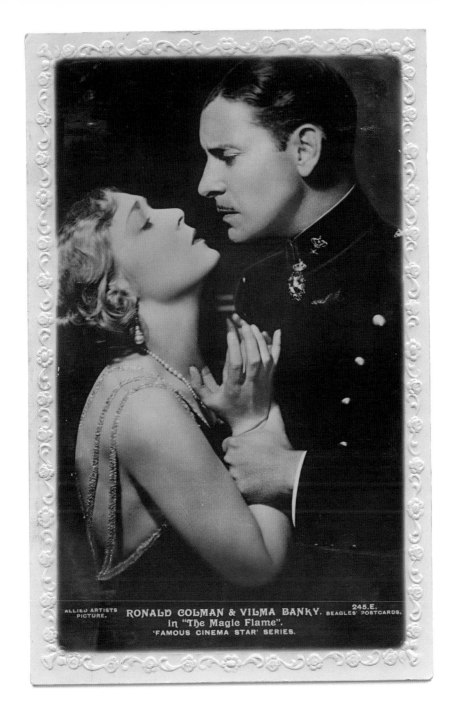

ALLIED ARTISTS PICTURE. RONALD COLMAN & VILMA BANKY. BEAGLES' POSTCARDS. 245.E.
in "The Magic Flame".
'FAMOUS CINEMA STAR' SERIES.

recurrence of moustaches: 'Early in the present century a clean-shaven fashion started, but the men who shaved soon grew their moustaches again. It was said, for one thing, that modern features are not so noble as the Georgian.' When the actor Charles Laughton made the newspapers in 1936 with the startling news that he was growing a beard and moustache, readers needed to be assured that the facial hair was solely for his upcoming film role as Rembrandt.

To many in the 1930s, moustaches were associated with Bright Young Things – bohemian young socialites – who embodied everything the older generation abhorred. Conservative parents despaired to see an incipient moustache appear on their son's upper lip, convinced that it meant he had become entangled with a 'fast' set. Newspapers also reported that a number of employers had banned staff from growing moustaches. As the *Yorkshire Evening Post* reported: 'the head of a leading firm of drapers in Regent Street refused to employ shopmen who wore moustaches or those who parted their hair down the middle. The Bank of England once issued an order forbidding clerks "to wear moustaches during business hours".' This last stricture caused much satirical comment.

Facial Hair in the Depression

As the world entered a period of deep economic depression, the twirling moustaches of the hedonistic 1920s suddenly began to seem far too jaunty for the times. In 1932, when competition for jobs was higher than it had ever been in living memory, and toeing the line was back with a vengeance, the author Warren C. Graham

published *How to Get a Job During a Depression*, which offered much-needed advice:

> Shave off that moustache if you're looking for a job. ... One of the
> most interesting details of seeking employment during a depres-
> sion has been the fact that moustaches in practically all cases
> have been a hindrance. ... A moustache [may] help in getting a
> job as a 'gigolo' or sheik, but there are practi-
> cally no openings for them during a depression.

On 14 May 1935 the *Yorkshire Post* reported on the
opening of a new club:

> Moustaches by the Yard. London will soon have
> a branch of one of the world's strangest clubs.
> This is the International Moustache (and Beard)
> Club, which was founded in Japan a little while
> ago, and now has a world-wide membership.
> Britain ... is only represented by Lord Wyfold
> and Sir James Crichton-Browne, the famous
> surgeon ... Sacramento, California, seems to
> suit beards, for it supports two clubmen with beards respec-
> tively seventeen and twelve feet long. The club's founder is Mr
> Yamaguchi, a well-known hotel proprietor in the Japanese Lake
> District. He carries moustaches twenty one and a half inches
> from tip to tip, thus beating by one and a half inches the first
> president of the club, the world-famous General Nagaoka, whose
> moustaches were preserved when he died.

Gaishi Nagaoka (1858–1933),
Japanese general and first
president of the International
Moustache (and Beard) Club

RECORD BREAKERS

Ram Singh Chauhan with his remarkable moustache

In 1967 the Smithsonian Institution in Washington, DC received the beard of Hans N. Langseth, who had been born in Norway in 1848 but emigrated to Iowa in the USA, where he had died in 1927. The beard was 17½ feet (5.33 metres) long – the longest on record – and can be seen on display at the Smithsonian today. The Wellcome Collection in London contains an image of a young girl using Langseth's beard as a skipping rope.

According to *Guinness World Records*, the world's longest moustache belongs to Ram Singh Chauhan from India. He has not shaved or trimmed his moustache in over three decades, and when it was officially measured in 2010, it extended to more than 14 feet (4.29 metres) in length. When interviewed by the *Daily Mail* in 2013, Chauhan commented, 'We are

Hans N. Langseth finding a novel use for his world-record-breaking beard

Rajputs. It's a common practice to sport a moustache in our clan. My father also sported a flowing one. Now my son has also started growing his.' His moustache has gained such fame that Ram Singh Chauhan is in demand from Bollywood and appeared in the James Bond film *Octopussy*.

By the mid-1930s in a recession-ridden Britain, moustaches had become the sign of a man gone to the bad, or of a Surrealist, which amounted to the same thing. The Surrealist artist Salvador Dalí had made moustaches the domain of the mad, the bad and the bohemian. When he was photographed with Man Ray in 1934, his moustache was of little note; photographed by Cecil Beaton in 1936, it had become so pencil thin that it seemed unreal; within a couple of years it had become internationally famous – long, lean and waxed to perfection. He often adorned it with flowers and other ornaments intended to make non-Surrealists' hackles rise. Little wonder that Dalí's moustache became a thing of legend and, in the early twenty-first century, it was voted the most recognisable moustache in history. In 1954, the year he was photographed by Philippe Halsman, Dalí was interviewed on television and asked if his moustache was intended to be a joke; he responded that it was 'the most serious part' of his personality.

While Dalí was still cultivating his facial hair, in 1934 the British press reported with great glee and derision that Austrian policemen had been recommended to grow moustaches in order to make themselves look more threatening to criminals. K.R.G. Browne, a much-loved author and satirist who worked regularly with the cartoonist W. Heath Robinson, published the following article:

> No one who takes an intelligent interest in policemen or moustaches, or both, can afford to disregard the controversy now raging in Vienna … The Viennese constabulary, it appears, have been advised to grow the fiercest possible moustaches with the greatest possible speed, on the ground that 'martial-looking

moustaches tend to frighten rogues' ... There are few spectacles so frightening as a very large moustache deftly wrought into twin spikes by means of fish-glue or some such unguent, and attached to a full-sized policeman.

The Beard as a Symbol of Rebellion

Facial hair has often been viewed as subversive. In the mid-nineteenth century the *Manchester Courier* announced: 'Since the late insurrection and massacre at Naples it is unsafe for any man who wears his beards and mustachios to walk the streets of that capital, as the *lazzaroni* [beggars] regard those hairy ornaments of the face as sure tokens of a republican.' In the 1960s, UK Foreign Office records reveal that members of the IRA were expected to be identified by their beards. It is also alleged that in the early 1960s the CIA hatched a plot to eliminate Fidel Castro's beard by infusing his clothing with thallium salts, which make hair fall out.

While the moustache was being regarded with suspicion in Britain – unless on a cinema screen – beards had once more begun to creep back into fashion, albeit almost entirely on older retired men and venerable academics and writers, all of whom had eschewed the daily regime of shaving in order to enjoy a respectable and bearded old age. This was not the facial hair of the dandy; this was a return to Victorian values and to the generation gap of the 'Naughty Nineties', when those very men now sporting beards had ridiculed their fathers and grandfathers for looking so outmoded. Many of the older men who had fought in the First World War and returned to a country altered beyond their wildest belief had begun to think that a return to old-fashioned values, in every sense, was preferable to the frightening Europe of the 1930s. The British writer and campaigner Rebecca West joined in the debate on facial hair in her 1936 novel, *The Thinking Reed*, in which she mused about the connotations of beards in different countries: 'In England and America a beard usually means that its owner would rather be considered venerable than virile; on the continent

of Europe it often means that its owner makes a special claim to virility.'

By the late 1930s, there were fears that Germany was once more preparing for war. As plans for a possible conflict began to take place, the old problem of gas-mask seals reared up again. In 1937 an announcement was made reminding people that gas masks would not work if worn with beards. This began a furious argument about why, yet again, the nation should be subjected to enforced rules on shaving. Why couldn't a gas mask be invented for those who wanted to keep their beards? It became seen as a battle between the old and the young. The *Exeter and Plymouth Gazette* reported:

> Though men with beards are now a small minority in this country, their number includes some distinguished exhibitors and all of them are deeply attached to their adornments. The brilliant but irreverent author who used to call beards and moustaches 'face fungus' is no more, and that rude game, said to have been invented at the University of Oxford, known as 'beaver spotting', has, happily, died out too. But the harsh alternative of either sacrificing a long-cherished beard or being poison-gassed is one that must give pause to even the most stoical of Poloniuses. The very fact that Whitehall adopts this autocratic attitude, and attempts no special design of gas-mask for bearded citizens, suggests how democratic ideas and veneration for elders are on the wane in this country.

Gas masks were not redesigned to accommodate facial hair, and after the Second World War beards were again firmly out of fashion.

Charlie Chaplin depicted on a cigarette
card by Alick P.F. Ritchie, 1926

Adolf Hitler in an American home-front propaganda
poster from the Second World War

Facial Hair in a Post-war World

After the Second World War, it wasn't just beards that were no longer in vogue: thanks to Adolf Hitler, the moustache had been given an understandably bad press. It was a brave man who wore a toothbrush moustache in this post-war era. Even Charlie Chaplin, who had made a similar moustache and his name world famous, wore his only on set. Yet not all moustaches were out of favour: the more flamboyant moustache was beginning to make a comeback.

In her 1948 novel, *I Capture the Castle*, author Dodie Smith posed the pertinent question, 'How can a young man like to wear a beard?' Once again beards and sideburns had become the domain of older men, venerable men, 'dinosaurs' too shaky to wield a razor. Beards had become the sign of a man in his dotage. Moustaches, however, were no longer the domain of degenerate artists. Instead they were now most commonly associated with the RAF pilots who had risked their lives so daringly during the Battle of Britain. Just as beards had denoted the heroism of the soldier after the Crimean War, and sideburns had caught on after the American

THE HANDLEBAR CLUB

In 1947 the proudly moustachioed actor Jimmy Edwards held a party in his dressing room at the famous Windmill Theatre in London's Soho. This would later become recognised as the inaugural meeting of the Handlebar Club. The Club still thrives to this day and spends much of its time raising money for charity (including taking part in Movember – see pages 133–5) and forging alliances with moustache clubs from other countries. Its newsletter, *Graspable Extremities*, takes its name from the Club's regulation that men who wish to become members must possess 'a hirsute appendage of the upper lip, with graspable extremities'. Applicants have to endure a club member grasping their moustache and tugging at both sides to ensure that it is real.

Men with beards are explicitly banned from joining.

The Club was newsworthy from the beginning, and in April 1947 the *London Evening News* published the following account of the founder's facial hair:

Jimmy Edwards' own moustache has had an interesting history; it is the fourth of its line. The first was posted 'missing' after an R.A.F. mess party. The second was removed for security reasons just before D-Day (F/Lt. Edwards, Pilot of a Transport Command aircraft, was deemed to look too English with such an appendage). The third was burnt off when its owner's Dakota was shot down on the way back from Arnhem. A D.F.C. was hardly adequate compensation.

Jimmy Edwards by Vivienne, late 1960s

Civil War, moustaches now marked out courageous fighting men. Moustaches were once again in favour.

This discussion of facial hair and its battle between the generations was parodied by author Reginald Reynolds in his 1950 book, *Beards: An Omnium Gatherum*. He discussed the history of beards and looked at the constant battle between old and young, and how beards had fallen in and out of fashion throughout the millennia. His book includes the satirical comment:

Therefore let those only who can be proud of their bodies, display them, and only those who believe their faces to be worth showing remove Nature's face-cloak. And beards shall be a form of purdah for males who lack chins or have mouths that are weak or ugly … Happy the shaven husband whose wife, having seen his features before marriage, could still sign the contract open-eyed and undeceived.

> '[Ivan Ivanovich] was a thin, fair-haired man, restless as an eel and with a wicked little beard which made him look like an American of Lincoln's time; he was always bunching it up in his hand and nibbling the tip.'
>
> Boris Pasternak, *Dr Zhivago*, 1957

The Arrival of the Hippy

By the 1960s, memories of the Second World War were finally diminishing. A new generation had been born and grown up with only their parents' recollections of the conflict. There was an urge to move into a new era, to move away from the military conformity that had clung to so many who had lived through war. As the hippy culture spread, increasing numbers of young people started growing their hair long and allowing their body hair and

facial hair to grow unchecked. This was anathema to many of those who had fought in the War and who considered long hair and beards a sign of degeneracy.

With the re-emergence of the beard, the old argument about beard bacteria also resurfaced, and in 1961, in a move reminiscent of the 1902 New York dairy ban on beards, the City of London issued new meat regulations:

> At Smithfield Market ... the Chief Meat Inspector invited all bearded meat porters to his office and explained that Regulation 8 required a person who engages in the handling of food while so occupied to take all such steps as may be reasonably necessary to protect the food from risk of contamination ... It is gratifying to note that only one beard now survives, and it is hoped the influence of his colleagues will induce the wearer to follow their example.

When the Beatles left behind their early 'moptop' image and began to favour long hair on head and face, they led the way for the youth culture of Britain to change entirely. As backpacking gained in popularity and increasing numbers of young people set off to explore the world, many border police began refusing entry to those they deemed hippies. Among the countries that turned travellers away, based solely on their appearance, were the popular destinations of Morocco, Algeria and Greece. Cartoons began to appear showing long-haired, bearded travellers being refused entry to Greece, while just across the border reposed classical statues depicting men with flowing hair and long, curling beards.

Following pages: The Beatles with Maharishi Mahesh Yogi in London by Philip Townsend, 1967

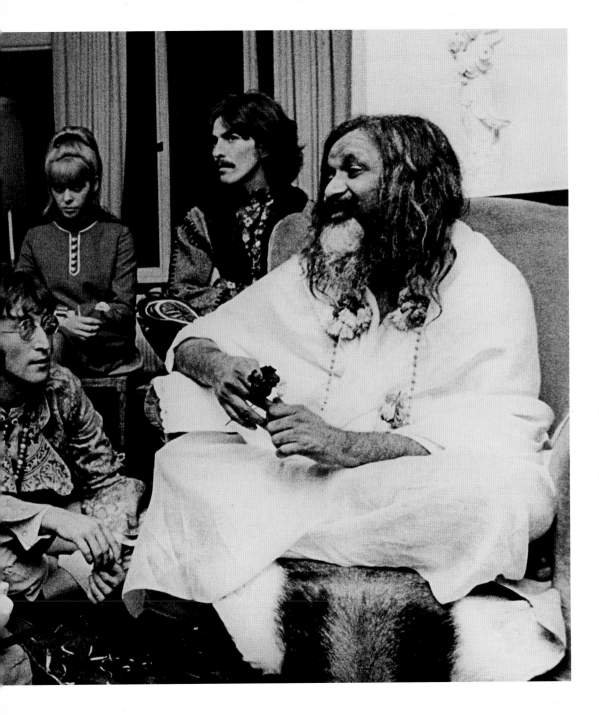

Just as had happened in the first decades of the twentieth century, employers started to query whether their staff should be allowed to grow their hair and facial hair. A memo survives in the archives of the Bank of England dated 2 August 1971:

> I confirm that the question of Messengers wearing beards has been discussed with the Chief of establishments who agrees that in this day and age the Bank should not insist on Messengers being clean shaven, but ... beards must ... be neat and tidy. It should be made clear to the Staff that the Bank do [sic] not expect the growth of any beard to be started during duty in the Bank ... A Messenger who grows a beard while on leave must expect to be asked to remove it if it is not of an acceptable standard by the time he returns to work. A Messenger wishing to grow a beard should seek the advice of the Front Lodge as to whether the wearing of a beard would be acceptable in his particular job/place of work.

In 1973 the *Journal of Psychology* published the results of a small study on the desirability of beards. Photographs of eight young men in various stages of facial-hair growth were shown to a panel whose comments were recorded. The conclusion was that the longer the facial hair, the more masculine and dominant the man was thought to be. By the late 1970s, however, the beard was on its way out. The generation who had fought against their non-bearded fathers was no longer young; it had been replaced by another generation, who in turn fought against their own parents' hippy ideals. The era of the punk, the skinhead and Generation X had arrived. Where beards had once been used to shock the older

The American actor Donald Sutherland captured in the process of removing his beard in 1970 by photographer Co Rentmeester

THE HAIR-FREE
FACE OF POLITICS

Although it would have been unthinkable for a British politician in the nineteenth century to be seen without facial hair, in twentieth-century Britain it was an entirely different story. Prime Minister Margaret Thatcher showed her 'iron lady' side by allegedly declaring she 'wouldn't tolerate any minister of mine wearing a beard'.

By the late 1990s, the era of Thatcherism was well and truly on the wane and, for the first time in years, it seemed like Labour might get a look in on the political stage. Up-and-coming Labour Party leader Tony Blair joined forces with his political spin doctors and began a concerted battle against the beard, with market researchers holding forums where voters were shown images of candidates with and without beards in an attempt to work out which would be more likely to lead 'New Labour' to that landslide victory. The tide seemed to be turning firmly in favour of the hair-free face.

There were, of course, those who defied the best efforts of the image consultants, notably David Blunkett and Robin Cook, but the majority of would-be cabinet ministers relinquished their beards to the razor. Even the humble moustache, such as that worn with such panache by a fresh-faced Peter Mandelson in the 1980s, was sacrificed to the gods of the ballot box.

The Labour Party's former Director of Campaigns and Communications, Peter Mandelson, now Baron Mandelson, by Steve Speller, 1988

generation, the bearded generation was now being horrified by the arrival of multiple piercings and shaven heads.

The Return of the Moustache

Daley Thompson by David Buckland, 1986

By 1980, the beard was out of favour with all but the most die-hard hippies, but the moustache was ready for a comeback. In 1980 the American actor Tom Selleck burst on to TV screens and into the hearts of housewives everywhere as the moustachioed maverick detective in *Magnum P.I.* Other actors quickly followed suit, even if their moustaches were often worn with irony, such as the quirky little 'tache' favoured by comedian Eddie Murphy. Selleck's much-lauded moustache has never been abandoned, and in the 1990s it gathered new followers with his role as Monica Geller's moustache-wearing boyfriend in *Friends*.

While *Magnum P.I.* was dominating television audiences, in 1980s Britain it was sportsmen who made the moustache sexy. When decathlete Daley Thompson won his first gold at the 1978 Commonwealth Games, he was on his way to becoming a household name. In David Buckland's photograph of 1986, Thompson wears his exuberant moustache with pride.

Formula One racing driver Nigel Mansell found his profile starting to rise after he joined the Williams team in 1985. Soon he and his much-discussed moustache were often to be seen in

newspapers and on TV. In 2011, when Sebastian Vettel became the first person to beat Nigel Mansell's 1992 record, Vettel appeared for the media sporting a fake (and bright orange) Mansell-style moustache – although Mansell had shaved his off after his retirement from Formula One some years earlier. In 2013 a song entitled *Nigel Mansell's Moustache* was released by Muscovy.

By the late 1980s and early 1990s, 'designer stubble' was the height of fashion, and special razors were designed to ensure a shave didn't remove the hair, but trimmed it to within a couple of millimetres. Pop stars, such as George Michael, made the look coveted by wannabe celebrities.

Longer hair for men was also firmly back in fashion, with very long hair having taken hold of the music industry by the 1990s. But long facial hair – and beards in particular – were completely out of favour. This was exemplified by Roald Dahl in his children's novel *The Twits* (1980):

Nigel Mansell in 1987

Mr Twit was one of those very hairy-faced men. The whole of his face except for his forehead, his eyes and his nose, was covered with thick hair. The stuff even sprouted in revolting tufts out of his nostrils and ear-holes. Mr Twit felt that this hairiness made him look terrifically wise and grand. But in truth he was neither of these things. Mr Twit was a twit.

By the 1980s and 1990s, the dominant facial hair of the previous two decades was regarded with derision, often evoking comparisons

Wham! (Andrew Ridgeley, left, and George Michael) by John Swannell, 1985

with the illustrations for a defining book of the era, *The Joy of Sex* (1972), by Dr Alex Comfort. When the book was revised and updated for its thirtieth-anniversary publication in 2002, it was proudly announced that it included pictures of a 'post-millennial couple' and that modern-day readers could 'say good-bye to the bearded satyr of old'.

An illustration by Chris Foss for the original 1972 edition of *The Joy of Sex*

A New Millennium and a New Fashion in Facial Hair

By the beginning of the new millennium, facial hair had been passé for so long that it had gained an almost iconic status – something unique and admired for being unusual. The minority group that now wore facial hair became a proud clique of those willing to be out of the ordinary. Men who were brave enough to sport full beards or waxed moustaches set up their own groups, and membership of organisations such as the Handlebar Club was booming. In the first decade of the twenty-first century, non-religious facial hair was worn almost exclusively by those who chose to be different.

This would change in the 2010s, as it became apparent that the full set of beard, sideburns and moustache was no longer a rarity. By then an idea that had begun in a bar in Australia as long ago as 2003 had become the international phenomenon that is Movember. It all started when a group of friends enjoying a beer in Melbourne

joked about bringing the moustache back into mainstream fashion. Women's cancers were getting a lot of publicity and fundraising, thanks to inspirational campaigning, and they realised that male cancers needed similar efforts to combat them. Out of that humble night at

Prince William in a press photograph taken in 2008

the pub, Movember was born – and began raising awareness about prostate cancer. The month of November would be renamed Movember, in honour of the moustache. In that very first Movember, thirty men grew moustaches and in subsequent years those who took part did so to raise money. The Movember charity was registered in 2006 and the concept of growing a 'mo' to highlight men's health concerns spread around the world, and it is estimated that over three million have been grown since 2003. Most men who had grown moustaches for Movember 2006 had shaved them off as soon as the charity-raising month came to an end; yet within a few years, the Movember moustache was starting to become a more permanent fixture, and men began experimenting with growing extra facial hair. In 2008, when Prince William grew a beard to make him less recognisable on a military mission, it made newspapers around the world and launched a 'Will he or won't he shave?' debate. The *Daily Telegraph* even queried whether having a beard would affect the Prince's suitability to be king.

Military regulations remain strict about the growth and main-tenance of facial hair, but the rules have been relaxed for those soldiers serving in Afghanistan and other countries where the

beard is considered a symbol of status. Once the soldier prince had returned from his special mission, he did shave – at the behest of his commanding officers because his mission was over and the beard no longer necessary. Of the three British military services, it is traditionally only the Royal Navy that permits its men to grow beards. To be allowed a beard, a sailor has to request 'permission to stop shaving'. He is then given two weeks to grow a 'full set' because a naval beard must always be accompanied by a moustache. After two weeks, his commanding officer decides whether the beard is satisfactory. If not, he will be ordered to shave. Similarly, if a bearded sailor wants to remove his beard and moustache, he must ask permission to 'resume shaving'.

A couple of years after Prince William's foray into the world of facial hair, his younger brother, Prince Harry, also grew a beard, which began another media circus, not least because of the bizarre reaction whenever a man with red hair chooses to grow facial hair. For some reason, 'ginger' beards are often considered less acceptable than beards of any other colour. Harry too bowed to pressure and eventually shaved.

The Movember effect, however, was starting to make moustaches sexy again, and many men were looking back to the Golden Age of Hollywood for inspiration. Recognising this, makers of men's grooming equipment began to capitalise on it. For example, the

World Beard Day

World Beard Day is celebrated annually on the first Saturday in September. According to the official website, on the day itself 'it is customary for the bearded members of a family to relax and partake in no jobs or chores. The beardless members of the family traditionally show their support by waiting on the bearded hand and foot. World Beard Day is all about promoting and elevating the global status of the beard. Whilst many countries and cities practice World Beard Day customs specific to their own region, shaving on World Beard Day is universally considered to be highly disrespectful.'

THE CONTROVERSIAL EUROVISION BEARD

In 2014, the Eurovision Song Contest was won by Austrian contender Conchita Wurst, who performed in a dazzling dress – and a sculpted beard and moustache. The drag artist, whose original name is Thomas Neuwirth, caused a commotion that extended far beyond the pop contest. While most viewers saw the dress-and-beard combination as a good gimmick, others saw it very differently.

Conchita Wurst has been hailed by some as an icon of gay and transgender rights and by others as a dangerous deviant. Some Orthodox church leaders held the Eurovision winner responsible for the devastating floods that surged through the Balkan region a week after the contest was televised. These church leaders claimed the floods, which forced more than 150,000 people from their homes, swept away buildings, destroyed villages, caused landslides and killed more than 50 people, were 'divine punishment' – and all because a bearded drag queen won the Eurovision trophy.

Conchita Wurst during her winning performance at the final of the
Eurovision Song Contest in Copenhagen, Denmark, in May 2014

Jeremy Paxman by
Vagner Vidal, 2013

Philips razor company began an advertising campaign, complete with instructional video, on 'How to create the Clark Gable moustache'.

In 2013, British TV journalist and presenter Jeremy Paxman grew a beard and was astounded at the storm of comments his new appearance generated. He hit back at the commentators and branded his employers, the BBC, as 'pogonophobic'. When Paxman shaved at the start of the following year, the event made the newspapers. When asked about his decision, he was reported to have commented 'Beards are *so* 2013.' Paxman must have considered himself in good company when, at the 2013 Oscars, beards were all over the stage. Photographs of newly bearded film stars George Clooney, Brad Pitt, Ben Affleck

and Bradley Cooper were dominating the media. By the summer of 2013 the re-emergence of the huge bushy beard on fashion-show catwalks was also international news. The *Daily News* reported from Paris, 'the full beard is back in fashion in France to the delight of the nation's barbers'. By the end of the year, whiskers, beards and moustaches were everywhere, and pogonophobes were hiding indoors. The beard and moustache in particular had reached a popularity level unseen for more than four decades. Once again, facial hair seemed set to stay. At the start of 2014 the *New York Post* reported on the number of hipster men who had sought out plastic surgeons for beard implants. 'It's sheer madness!' proclaimed the newspaper.

> **'The truth is, growing a beard is a bit like raising a child: you hope they'll turn out right but you can never really tell until they're fully grown what the outcome of your nurturing is. Some men, of course, simply aren't meant to be parents.'**
>
> Lee Kynaston in the *Daily Telegraph*, 12 September 2013

The University of New South Wales seemed inclined to agree. In early 2014 it published the results of its study into the desirability of men with beards. Men and women of all sexual orientations had taken part in the study, which asked them to describe their responses to men with facial hair. Some recipients were shown a series of images in which only a small percentage of the men had facial hair; others were shown images in which facial hair dominated. Researcher Robert Brooks summed up the study to an Australian newspaper: 'It appears that beards gain an advantage when rare, but when they are in fashion and common ... that attractiveness is over.' The world's media jumped on to the beard bandwagon, and articles and bulletins immediately began asking, 'Have we reached Peak Beard?' Whether the fashion for facial hair will survive or whether the razor will come out of retirement remains to be seen.

INDEX

Note: page numbers in **bold** refer to captions.

ACKNOWLEDGEMENTS

Thank you very much to the following people and institutions who have helped with the research for this book. In alphabetical order they are: Sherman Alexie, Bank of England Museum, Dr Richard Barnett, British Library, Paul Carlyle, Robert Hershon from Hanging Loose Press, John J. Johnson, Berwyn Kinsey, Rod Littlewood and the Handlebar Club, London Library, National Archives, Constantia Nicolaides, Terence Pepper, Liz Rideal, Royal College of Physicians, Wellcome Library and Lorna Williams. Thanks go also to Christopher Tinker and Nicola Saunders at National Portrait Gallery Publications and to Broo Doherty at DHH Literary Agency.

PICTURE CREDITS

Full details of works held in the Collection of the National Portrait Gallery, London (including media, dimensions, accession numbers, further information about sitters and artists, and in most cases an image of the complete work) can be found using the search facility on the Gallery's website at: www.npg.org.uk/collections

Published in Great Britain by National Portrait Publications,
National Portrait Gallery, St Martin's Place, London WC2H 0HE

For a complete catalogue of current publications, please write
to the National Portrait Gallery at the address above, or visit our
website at www.npg.org.uk/publications

First published 2014

ISBN 978 1 85514 493 4

10 9 8 7 6 5 4 3 2 1

A catalogue record for this book is available from the British Library.

Managing Editor: Christopher Tinker
Copy-editor: Patricia Burgess
Page design: Matthew Young
Production: Geoff Barlow, Ruth Müller-Wirth

Printed and bound in Slovenia

Page 2: Wilkie Collins by Rudolf Lehmann, 1880